Shoebox Holography

Shoebox Holography

A Step-by-Step Guide to Making Holograms Using
Inexpensive Semiconductor Diode Lasers

**By Frank DeFreitas, Alan Rhody
and Stephen W. Michael**

Ross Books, Berkeley

Ross Books
P.O. Box 4340
Berkeley, California 94704
Printed in the United States of America

DeFreitas, Frank

> Shoebox Holography: A Step-by-Step Guide to Making Holograms Using Inexpensive Semiconductor Diode Lasers

> Includes index

1. Holography—Handbooks, Manuals

2. Photography, Abstract—Handbooks, Manuals

3. Lasers, Semiconductor Diode—Experiments

I.Rhody, Alan, joint author.

II. Michael, Stephen W., joint author.

III. Title

ISBN: 0-89496-060-1

Credits: Text, design and layout by Alan Rhody. Based on the work of, and with assistance from, Frank DeFreitas and Stephen W. Michael. Photographs provided by Scott Chernis Photography, Stephen W. Michael and Ross Books. Special thanks to John Klayer for his work with fiber optic holography. Cover design by Stephen W. Michael.

Acknowledgments

This book was inspired by another, the *Holography Handbook.* It is dedicated to the authors and publisher of that title.

Table of Contents

Foreword

Shoebox Holography fulfills a need that has existed since the discovery of holography: the desire for inexpensive, readily available materials and a simple methodology that will ensure the successful creation of a hologram.

When I began making holograms in 1970, there were no step-by-step practical guidelines, only textbooks and scientific papers filled with complex equations and generalized holography recording arrangements. My single beam reflection holograms were almost always successful, but my ultimate goal was to produce more sophisticated images. For most of the '70s, I was able to accomplish and perfect my goal by trial and error, learning unpublished secrets like correct polarization, path lengths, and beam intensity ratios.

In August 1996, I published my multibeam techniques on the Internet using step-by-step procedures so anyone could successfully make display holograms. My site was well received by amateur holographers. But the cost of building my holography recording system was still out of reach for most people. In early 1998, I started receiving emails from people wanting to know if a hologram could be made using a laser pointer. I honestly didn't know and said so. I had heard through the grapevine that it couldn't be done, because a pointer had inadequate coherence and polarization. I decided to find out for myself. I bought a laser pointer and found myself once again working with single beam holograms. I tested the laser's coherence and polarization and found them to be very adequate. I set up a single beam reflection arrangement and successfully produced a high quality hologram on a 4" x 5" plate. The cost of a laser for creating holograms had just been reduced to less than $20, removing an expensive part of hologram creation.

My single beam results were confirmed by Frank DeFreitas, using a different laser pointer bought for less than $10. Frank went on to created his *Shoebox Holography* booklet, meeting the need for an inexpensive and successful methodology for creating quality display holograms for the beginning holographer. There is definitely a moral to this story: sometimes you just have to find out things for yourself.

Stephen W. Michael, Holographer

Preface

This book is a do-it-yourself, step-by-step guide to building a hologram recording system with a minimum of expense and space. By following the instructions in this book you can produce three dimensional holographic images in your own home or classroom. Because all the needed components can be packed into a small box, I call my production method "shoebox holography."

Lasers are needed to make holograms. Until recently, a suitable laser cost hundreds or thousands of dollars. The Shoebox Holography system is based on inexpensive, low-power semiconductor diode lasers. This type of laser can be found in CD and DVD players, supermarket scanners and even in ordinary laser pointers. It's hard to believe a laser suitable for basic holography can now be purchased for less than $10!

As far as I know, Stephen Michael of Three Dimensional Imagery was the first person to successfully produce visually striking holographic images using the laser in an inexpensive pointer. Within a few days of his December 1998 experiments, I confirmed Steve's results. Since that time, we have created an entirely new way of making various types of holograms using these semiconductor diode lasers. This book will teach you one of the production methods we developed.

Besides a laser, you will need to collect an assortment of other easily obtainable items. Most of them are available at your local hardware or electronics store. Depending on where you are located a few may have to be ordered from suppliers listed in this book.

To close this introduction, I would like to tell you about Brittany and Samantha. The girls wanted to make holograms for their metro science competition using the Shoebox Holography system. Their science teacher told the girls' parents it couldn't be done. So their parents brought the girls to my studio, where they learned more about the process. Then they set up a Shoebox Holography system at home.

On Sunday, March 7, 1999, Brittany and Samantha took first place in their metro science competition for creating a hologram using a semiconductor laser. Brittany and Samantha are in the sixth grade.

Frank DeFreitas, Holography Instructor

Note for Instructors

In addition to learning how to work with lasers and make holograms, the Shoebox Holography system will also give your students experience with:

- making a hologram of an object
- viewing a 3D image
- basic principles of physics and laser theory
- working with semiconductor diode lasers
- working with fiber optics
- simple lenses and their effect on light
- conducting a scientific experiment
- working with metric measurements
- working with photochemistry
- working with magnets
- constructing a simple electrical circuit
- measuring angles
- a vibration isolation system
- artistic design and creation
- critical thinking and troubleshooting
- reaching conclusions

Educational Recommendations

"Shooting laser diode holograms will revolutionize the way students and educators are introduced to creating holograms. The SHOEBOX HOLOGRAPHY method makes creating holograms with laser pointers fun and accessible to all students and educators. By using laser diodes, we will be increasing the number of students being able to create holograms in our programs."

Otto E. Loggers, Education Coordinator, The Massachusetts Institute of Technology Museum

"This book is excellent, you have touched on many little important details that others have not.... Congratulations. You have approached the subject from a direction of simplicity, with the important factors that make a hologram possible. I like a lot of your tips."

Jeffrey Murray, Professional Holographer and Holography Instructor

"I want to thank you for doing what we all should have done and simplifying the process by using the diode lasers. I tried your Shoebox Holography instructions last weekend and they worked very well. The first hologram came out perfectly and we are going to start doing the demonstration again because we are getting a new hologram exhibition starting this next weekend."

Ed Brown, Physics/Chemistry Teacher, Science Demonstrator, Science Center of Iowa

Note - See Appendix B for additional information regarding careers in photonics.

About Holography

Introduction

Overview

Shoebox Holography is a step-by-step guide to making holograms that is based around using an inexpensive semiconductor diode laser as a light source. Using this type of laser (found in laser pointers) and other readily obtainable supplies, you can record high quality holograms in your classroom, laboratory or home. By following the instructions in the book you will produce a fascinating three dimensional image unlike any photograph you have ever seen. And you will be able to easily display your hologram to others.

The Shoebox Holography experiment can be successfully performed by students, hobbyists, and researchers with various education and skill levels. The instructions are detailed and precise, but easy to understand. In brief, the experiment consists of 1) building and assembling simple components, 2) making an exposure on a special photosensitive recording material using the light emitted by a laser and 3) processing the resulting hologram using common photographic darkroom techniques. (It is recommended that an informed adult or qualified instructor supervise all procedures.)

Section One: About Holography

In addition to the hands-on experimental procedures, this book includes theoretical and practical information about holography, lasers and fiber optics.

Chapter 1 explains the principles upon which the Shoebox Holography experiment is based. (Having an understanding of basic optics is useful for the reader, but not necessary.)

Chapter 2 relates the history of holography and lists some modern commercial applications of the technology. The subject matter should appeal to anyone considering working in the field.

Chapter 3 introduces important physical principles related to photonics and explains laser theory in relation to holography. Certain lasers, (including semiconductor diode lasers) are discussed in detail.

Section Two: Preparing for the Experiment

Chapter 4 lists all the equipment you will need to gather in order for you to assemble a hologram recording setup and a hologram processing darkroom. You will need to acquire a suitable laser, recording materials, the appropriate photochem-

istry, and a small lens. Most of the other equipment that is used in the experiment can typically be found around the house (or classroom) or purchased at a local electronics outlet, hobby shop or hardware store. Helpful lists and charts are included.

Chapter 5 provides detailed equipment specifications and suppliers' contact information (if you choose to order your supplies from mail order businesses, science product catalogs or Internet web sites.) The Shoebox Holography experiment is intentionally designed to be affordable to perform, however, it is recommended that you work with a partner or group so that you can share expenses.

Section 3: The Experiment

The main experiment begins with Module 1. You will learn how to prepare your laser for recording holograms by insuring it has an adequate power supply. You may choose to wire your laser to a set of ordinary "flashlight" batteries.

Modules 2 and 3 will teach you how to assemble and set up the components needed to record a hologram. First, you will build component mounts for the laser and the lens from simple hardware supplies. Second, you will build a small platform (a vibration isolation table) to hold the object (the thing you are making a hologram of) and the hologram recording material (a small sheet of specially coated glass). Then you will arrange all the components in a simple hologram recording setup. This involves lining up the components and aiming the laser beam through the lens at the glass plate (and at the object positioned behind it).

Modules 4 and 5 will teach you how to prepare the photochemical solutions that are needed to develop and process the type of hologram recording material that you will employ. It will also teach you how to set up appropriate darkroom facilities. Having previous photographic darkroom experience is handy, but not mandatory. You are required to follow standard darkroom safety practices.

The actual hologram recording procedure commences with Module 6: Loading the Plate. Once everything is ready you will unpack a single small glass hologram recording plate and place it in its holder on the vibration isolation table. Then you will move a shutter aside and expose the plate (Module 7) to laser light for a short time (i.e., record a hologram).

To simplify the hologram recording process a bit: 1) the laser light passes through the glass plate and illuminates the object positioned behind it. 2) Some of the laser light reflects off of the object and back onto the plate. 3) The two sets of laser light waves traveling from opposite directions meet in the photosensitive emulsion coated on the plate and interact. 4) This exposes a microscopic pattern in the photosensitive emulsion on the plate, not a recognizable image. The pattern is called a hologram.

This particular hologram recording setup produces what's called a reflection hologram. Formerly, such a hologram was relatively costly to create, mainly because of the expense of operating and maintaining finicky lasers. Small and rugged semiconductor diode lasers make the process much more practical to perform.

In Module 8 you will learn how to develop and process your hologram using standard photographic darkroom procedures. This involves immersing the exposed hologram recording plate in a series photochemical solutions and water washes. You will employ a developer, a bleach, two water rinses and possibly a drying agent.

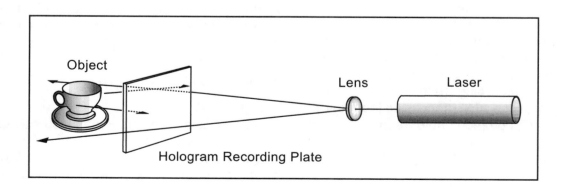

Object

Lens Laser

Hologram Recording Plate

When the processed hologram dries (using the methods described in Module 9), you will be able to see a holographic image. (Exposing and processing the hologram should be able to be completed in a single classroom period.)

Module 10 instructs you how to best view the resulting holographic image, as your hologram must be illuminated correctly. An ordinary spotlight or direct sunlight works well. Once the hologram is properly positioned, a realistic-looking image of the object that you made a hologram of will appear just behind the surface of the glass plate. The image will have depth and dimension. You will be able to see around the sides of the image as if it was located behind a little handheld window.

Module 11 introduces another important technology in the field of photonics—fiber optics. This experiment explains how to make a fiber optic bundle and integrate it into a hologram recording setup. The experiment involves sending laser light through the fiber optic strands as is done in many modern communication devices.

Though doing these experiments is educational, performing them is intended to be enjoyable. Have patience and don't give up if your first results are unsatisfactory. Making high quality holographic images is an art as well as a science.

In addition to the sections of the book mentioned, there are three appendixes and an index. Appendix A provides an alternative developing and processing method. Appendix B provides career development information for those interested in working in the photonics industry. Appendix C lists important vocabulary words that appear throughout the text of the book.

Holography vs Photography

Holography is often compared to photography. It is common to say they are both ways to record images of objects. In general, they are similar. Both techniques involve exposing a photosensitive material to light. Both techniques include photochemical developing and processing steps. Both techniques result in flat sheets of material that can be held or hung on a wall for display. But the way that images are recorded and produced is quite different.

An exercise: Once you do complete the Shoebox Holography experiment, compare a view of the actual object you recorded with a similarly sized photograph of that object. Then compare those with the holographic image that you produced. What differences do you notice?

Ordinary Photography	Shoebox Holography
major elements are camera, any light source and the scene being recorded	major elements are recording material, a special light source and a small object
recording takes place in a camera	recording takes place in a darkened room
recording material is photosensitive film	recording material is photosensitive glass plates
film is coated with regular emulsion (B&W or color)	glass plates are coated with special, high resolution B&W emulsion
ordinary light exposes film	laser light exposes the glass plate
a lens is used to focus scene on film	a lens is used to expand the narrow laser beam enough to cover the glass plate
the scene can be close or far away from the camera	the object must be close to the glass plate
exposures last fractions of a second	exposures last 15 seconds
a two dimensional representation of the scene is recorded	three dimensional visual information about the object is being recorded
a pattern of light passing through an aperture (and lens) is being recorded	the pattern that results from two converging beams is recorded
There is a lens between the scene and the film	there is no lens between the object and the glass plate
exposed film is developed and processed in a photolab	hologram is developed and processed in a darkroom
can see a picture after developing film	can see a clear plate after developing hologram
can view the picture in regular room lights	hologram must be illuminated properly with a bright single point source to produce a viewable image
the photograph is flat	the hologram is flat
the photographic image is flat and displays no parallax	you can look around the sides of the holographic image
the resulting picture is not the same size as the scene	the resulting image is the same size as the object

Chapter 1

Basic Concepts

This chapter explains what a hologram is and how a holographic image is produced. The Shoebox Holography experiment is introduced.

A Simple Description of Holography

For the purposes of this book, holography can be described as a specific way to record and reproduce a set of light waves that originate from a three dimensional object. The recording, called a hologram, is made by exposing a piece of high-resolution photosensitive material with laser light. After the photosensitive material is processed, the hologram is ready to be displayed. When a beam of light shines on the hologram in just the right way, a person looking directly at the hologram will see a three dimensional holographic image of the original object.

This simplified description covers some important points related to holography in general as well as to the Shoebox Holography experiment detailed in this book. Let's discuss in more detail each sentence in the description.

"...a specific way to record and reproduce a set of light waves that originate from a three dimensional object." Holography was defined by its inventor, Dennis Gabor, as a "two-step method of optical imagery." The first step involves recording a set of light waves that have been reflected off an *object* (the subject) using a special optical technique. The second step involves reconstructing those light waves in order to create a visible image of the object. To use more familiar terms, first you must record a hologram, then you need to "play it back" in order to see a holographic image.

Shoebox Holography will teach you an easy way to record and reproduce a three dimensional holographic image of a small object found in your house or classroom. The step-by-step instructions are highly detailed but simple to follow. After obtaining all the necessary components, you will arrange them in a hologram recording setup. You will then record a hologram and process it. Shortly after, you will be able to see the results of your work—a fascinating holographic image of the object you made a hologram of. It will not look like any photograph you have ever taken!

"The recording, called a hologram... " A hologram is the actual recording of the light waves reflected from an object using the hologram recording process. The word hologram was coined from two Greek words that roughly translate to *whole message* or *whole picture*. The term refers to the fact that the hologram recording method records more visual information than conventional

photography does. Therefore, the hologram can reconstruct a three dimensional image instead of just forming a flat two dimensional photographic picture.

The Recording Material

"is made by exposing a piece of high-resolution photosensitive material..." Since holograms record light waves, the recordings are made on a piece of photosensitive material (emulsion), a material that reacts to light. Because light waves are extremely small (their size is measured in billionths of a meter), the photosensitive material needs to have very high resolution. Holography film, similar to the film used in ordinary cameras, is one such photosensitive material. Other photosensitive materials used for hologram recording include: photopolymer (a plastic compound), DCG (a chemical-gelatin mix) and photoresist (a chemical solution used to create surface relief renditions, or etchings, of images).

During the Shoebox Holography experiment, you will record a hologram on a small sheet of glass that has been coated with a high-resolution photosensitive emulsion. This emulsion contains the same type of photosensitive compounds (called silver halide) as ordinary photographic film, but the emulsion is manufactured especially for use by holographers. The coated sheet of glass, called a *recording plate,* is easier to work with than a piece of flexible film when making your first holograms. Hologram recording plates can be ordered from suppliers listed in a following chapter.

The hologram is recorded on the recording plate during an exposure process. The exposure process typically lasts from a few seconds to a few minutes. For instance, the Shoebox Holography experiment recommends making an exposure lasting 15 seconds.

The Laser

"with laser light." All holography recording methods are based on using light that has certain uniform optical characteristics. A laser is a device that emits such light. Until recently, the price of lasers suitable for making holograms ranged from hundreds to thousands of dollars. In addition, these lasers often required highly skilled technicians to operate and maintain them.

In contrast, the Shoebox Holography hologram recording technique is based on using light emitted from an inexpensive semiconductor diode laser. This is the same type of laser found in ordinary laser pointers. These laser pointers typically cost from $10–$20. They can be easily used in a hologram recording setup.

The laser is not used to burn or etch a pattern into the material (the semiconductor diode lasers used in laser pointers are not powerful enough to do that). It is merely used to expose the film, similar to the way "regular light" exposes the film in a conventional camera. To record a hologram, the beam of laser light is used to illuminate the object you want to make an image of. The laser light strikes the object and reflects back onto the recording plate. (See figure 1.1.)

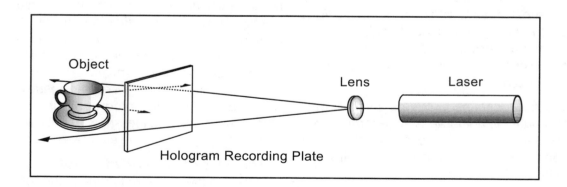

Fig. 1.1. Light from a laser is used to illuminate an object. The light reflects from the object and exposes the hologram recording material (a glass plate coated with a specially formulated, high-resolution photosensitive emulsion).

The Object Wave

The set of light waves that bounces off the object, called the *object wave*, directly corresponds to the shape of the object. For instance, if you used a coffee cup as your object, the object wave would be shaped like a coffee cup. If you used a book, the object wave would be shaped like a book. In addition to shape, the object wave provides information about the size, color, texture, and reflectiveness of the object.

In essence, our eyes collect object waves (light reflected from things around us) so that our brains can construct a visual representation of the world. Photographic and video cameras also record object waves to make two-dimensional pictures. Unlike photography or video, the object wave in a hologram recording setup is only one of two sets of light waves that need to be simultaneously recorded on the plate in order for you to make a hologram — and thereby generate a three dimensional image. (The other set of light waves, called the reference beam, will be discussed later in this chapter.)

When the object wave strikes the hologram recording plate, the laser light changes the molecular structure of the silver compounds in the photosensitive emulsion in accordance to the shape and intensity of the object wave, thus recording the complete visual information of the original object.

"After the photosensitive material is processed..." Once a hologram has been recorded in the recording plate, the plate needs to be processed in order to make the recording permanent. Different photosensitive materials are processed in different ways. For instance, photopolymer materials are processed with ultraviolet light and heat. Holograms made on DCG need to be sealed between two pieces of glass (so that the moisture in the air does not dissolve the emulsion). Photoresist materials are processed with solvents.

Since you will be using a recording material that is similar to the film used in an ordinary camera, it needs to be developed and processed using standard photographic darkroom techniques. The instructions for the Shoebox Holography experiment will teach you how to set up a suitable darkroom and provide you with step-by-step processing instructions.

In brief, you will immerse the exposed recording plate in several solutions of chemicals and wash baths. You will need to use a developer and a bleach, and perhaps a drying agent. These photochemicals can be readily obtained through many suppliers. Hologram processing kits containing pre-measured amounts of the necessary chemicals can be ordered from a supplier listed in a following chapter.

Reconstructing the Image

"When a beam of light shines on the hologram in just the right way..." Just as a music CD needs to be played to be heard, a hologram needs to be "played back" in order for an image to be seen. Image reconstruction is the second step in the holographic method.

As explained in more detail later, a hologram must be illuminated with a single beam of bright light in order to produce a high quality image. To better understand how this image reconstruction

Fig. 1.2. A drawing of an interference pattern created when two matching sets of laser light waves meet. The dark bands produced are called fringes.

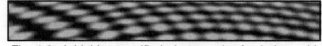

Fig. 1.3. A highly magnified photograph of a holographic interference pattern.

process works, it is necessary to know that when the object and reference beams meet at the recording plate during the recording process, they interact with each other and create a pattern that looks like a swirl of interlocking, microscopic lines. These lines are called *fringes*. They are microscopic patterns in the emulsion and can only be seen with a microscope. All the fringes together make an *interference pattern.* (See figures 1.2 and 1.3.) In fact, a hologram can be defined as an interference pattern that has been recorded using a certain optical arrangement.

Interestingly enough, if you examine an exposed and processed hologram closely, you will not see a recognizable image, only a clear glass plate with a slight yellow tint. It is an important to know that you can't see a image of the recorded object in the hologram unless you use the proper "playback" method called reconstruction.

During this image playback step, a beam of light enters the plate (hologram) and is affected by the interference pattern recorded in the plate. As light passes through the fringes that make up the interference pattern, the fringes "bend" the incoming beam into a copy of the light waves that originated from the object, thus creating a three dimensional image of the original object, in space, at a distance equal to the object's original distance from the plate. In essence, the incoming light waves are focused by the hologram into a visible three dimensional image of the original object. Actually, the incoming light is diffracted into a visible image; the word *diffraction* refers to the way a light wave is bent when it passes through a small aperture. (Two fringes side by side form that aperture.)

The result is called a *holographic image.* In popular usage, the term hologram is often used to name the image too, though a hologram is actually the recording itself. (The word holograph has another, unrelated meaning, though some

holographers have adopted it for their use.)

As noted, if the light waves originally recorded on the plate were reflected from a coffee cup (the object), the hologram would reconstruct light waves in the shape of a coffee cup from the incoming beam. If light waves in the shape of a book originally struck the recording plate, the hologram would reconstruct light waves in the shape of the book.

The beam of light used to illuminate the hologram must strike the plate from a predetermined angle. This angle is related to the way the recording plate was positioned during the hologram exposure process. To reconstruct a holographic image of the object you have holographically recorded using the Shoebox Holography technique, you light your hologram from the side using a flashlight, a spotlight or direct sunlight. (See figure 1.4.)

Viewing the Image
"a person looking directly at the hologram..."
To see a holographic image best (or at all), you must be positioned properly. Holograms made for artistic or commercial displays generally position the holographic image to appear in front, behind or straddling the surface of the recording plate. The best viewing position is usually directly in front of the hologram, your eyes level with the center of the recording plate. (See figure 1.4.) If a viewer moves too far out of the viewing zone, the holographic image will not be visible.

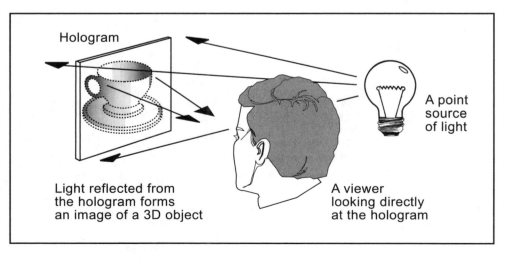

Hologram

Light reflected from the hologram forms an image of a 3D object

A point source of light

A viewer looking directly at the hologram

Fig. 1.4. A holographic image is generated when a properly positioned light source illuminates a hologram. The incoming light waves are reflected back to the viewer. The fringes that make up the hologram (a recorded interference pattern) diffract the light into a 3D image that a viewer can see.

It is important to point out that, unlike what you might see on television or at the movies, it is not possible to have a holographic image "hanging in mid-air." The floating images you may see at an amusement park or in video arcade games are not holographic—they are produced by other means. If you are standing in front of a hologram, the image can appear to project out of the picture frame, but you can't project holographic images in the middle of a room so you can walk around them. The laws of nature dictate that light will travel in a straight line unless it reflects off something back to your eye. In other words, you need to use a screen of some sort when projecting a photographic slide, a laser light show or even a hologram. However, holographic images projected onto a flat screen will look flat—which defeats the purpose of making them.

Unique Image Characteristics

"will see a three dimensional holographic image." You could make a hologram of a flat, two-dimensional, object but the most notable characteristic of the holography method is its ability to reconstruct realistic-looking, three dimensional images. In other words, if the light waves from a 3D object (like a coffee cup) were recorded, the resulting holographic image would be 3D. A viewer would be able to see a certain distance around both sides of the holographic image of the cup, over it and under it. The ability to see around the sides of objects (and images) is called *parallax* and it is part of the visual perception process. Parallax helps us perceive depth.

A photographic image, being flat, has no parallax. Systems have been devised that present two near-matching photos, or pictures, to a viewer in an attempt to fool the brain into seeing a 3D image (perhaps you are familiar with Viewmaster™ binocular viewers, have seen a stereogram dot poster or have tried on a pair of 3D glasses), but the resulting stereoscopic images also have no parallax. The 3D pictures with the ribbed, plastic surface, called lenticulars, can display pictures with depth and motion, but lack of parallax makes the images look rather unnatural.

In addition to parallax, holographic images also exhibit image projection and image depth. One of the most fascinating things about holograms is that it is possible to have the holographic image focused a few centimeters (or inches) or more in front of the recording plate. One very popular holographic image that is often displayed in galleries is of a projecting water faucet. To a properly positioned viewer it looks like a solid faucet projecting out of the picture frame. In fact, a viewer would be able to pass his or her hand right through the "ghost-like" image. Since it is only diffracted light waves that create an apparently solid image, artistic holography has been aptly described as "sculpting with light."

A holographer can also create images that appear to recede a few centimeters (or inches) behind the hologram. When you view the finished hologram that this book teaches you to make, you will see a highly detailed image of the object you recorded behind the recording plate. It will be like looking through a tiny windowpane at the object. A viewer looking through a larger holographic "window" could see a 3D image of an entire room, if that scene were recorded during the exposure process. One day in the future, holograms depicting landscapes may be hung in windowless rooms to provide realistic-looking vistas for the enjoyment of the occupants within.

In addition, since holograms are recorded using light waves and extremely high-resolution recording materials, the tiniest details of a subject can be captured. For instance, holographic portraits can show every single strand of hair on a model's head. Doctors and dentists are even able to take precise measurements from holographic images when it is impractical to work on a patient. Some high-quality full-color holographic images seem indistinguishable from the real thing.

More About Lasers

In the preceding pages you learned that a hologram is a recording of an interference pattern. To create an interference pattern for a hologram, you can't use just any light waves. You need to use light waves that are identical to each other, light waves that have the same frequency, color, and orientation. Light waves that are identical to each other are said to be *coherent*.

The sun, or any other source of white light (like a normal lightbulb) can't be used to record holograms because white light is a jumble of many different light waves, that is, it is incoherent. As you will learn by reading the history of holography later, the early holographers were unable to create good holographic images because they

didn't have access to a suitably coherent light source. They tried using the light from a highly filtered mercury-arc lamp, but it limited their progress.

A perfect light source for recording holograms did become available in 1962, when lasers were introduced. A laser is a device that emits a steady stream of identical light waves. All the light waves emitted have the same frequency, color, and orientation. That is why when you see a single laser beam it is all one color. (You will learn more about lasers used for holography.)

Originally, the lasers used to make holograms were large, complex and expensive. Today, they are miniaturized to the point that they can fit inside your pocket. The experiment described in this book is based on using such a laser. It is called a semiconductor diode laser. Basically, it is a tiny block of layered materials with a small space between the materials. When a little electrical current is put into one side of the device, photons (the basic unit of light) are produced. These photons start bouncing around the small cavity and multiply. At a certain point a steady steam of identical photons is emitted from the tiny opening in the diode. This is the *laser beam*.

The diode lasers used in the experiment described here emit a red beam of light. They are just powerful enough (2–5 milliwatts) to expose a recording material (manufactured to be sensitive to red light) for a reasonable period of time.

The Hologram Recording Setup

The three basic components in any hologram recording setup are: the object being recorded, the hologram recording material and the laser. To perform the Shoebox Holography experiment, you will also use a lens.

As a ray of light travels through transparent materials of different thicknesses, it is bent or *refracted* in various directions. A *lens* is a specifically shaped transparent material, typically glass or plastic, used to diverge or converge rays of light in a desired path. (Ordinary eyeglasses are based on this principle.) As a ray of light travels through the lens, it is bent or refracted in various directions, depending on the type of lens used. Since a diode laser emits a very narrow beam and the recording plate you will use measures 6.35

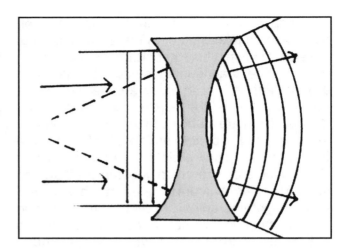

Fig. 1.5. A double-concave lens is used to expand the narrow laser beam enough to cover the recording plate.

cm (2.5 inches) square a lens is needed to expand (diverge) the beam on its way to the plate.

Different types of lenses can be used, but the most practical is a small, double-concave lens. Both surfaces of a double-concave lens are curved inward. (See figure 1.5.) These lenses are readily available at many science stores and hobby shops. They can also be ordered from a supplier listed in a following chapter.

Before describing how the components are arranged, it is useful to examine the exposure process in more detail. The way a holographic interference pattern needs to be recorded determines how the various components will be arranged.

Creating an Interference Pattern

You have already learned that in order to record a holographic image of an object, the laser beam travels from the laser to the object. The laser beam reflects off the surface of the object (like a coffee cup) and transforms the laser beam into a complex object wave. This object wave then travels to the recording plate. The complete optical path of the light traveling from the laser to the object to the plate is called the *object beam*.

To create a holographic interference pattern, you need to have a *second* set of light waves travel directly from the laser to the recording plate, without striking the object at all. This set of light waves (optical path) is called the *reference beam*. It remains pure and undistorted. Since the reference beam comes from the same laser as the object beam, both beams have identical beam characteristics prior to the object beam striking

the object. This is necessary for an interference pattern to form in the recording plate.

When the two matching beams (object and reference beams) strike the recording plate simultaneously, they combine to form what's called an *interference* pattern. This interference pattern is what is exposed on the recording plate. This is the basis for making all holograms—getting an object beam and a reference beam to successfully expose an interference pattern on a recording material. This is a unique hologram recording method that Dennis Gabor devised.

Holograms can be made using a single laser beam or multiple laser beams. Shoebox Holography uses the single laser beam setup where one beam is used for both the object beam and reference beam. Multiple laser beam setups (also known as split beam holography) uses the single beam from a laser also, but splits the beam into two beams (object beam and reference beam) by using a special piece of glass called a *beamsplitter*. The beamsplitter lets some of the laser light pass right through it (creating one beam) and reflects the remaining light (creating a second beam). One of the beams is used as the object beam which travels to the object which then reflects the light to the recording plate. The other beam is used as the reference beam which is aimed directly at the recording plate at a specific angle. Since both beams originated from the same laser, both beams have identical characteristics.

Reflection Holograms

There is a simple way to arrange the basic components of a hologram recording setup so you can make a reference beam and an object beam meet at the recording plate without using a beamsplitter. If the recording plate is placed between an expanded laser beam and the object, the light waves will pass through the recording plate (since it is a clear sheet of glass coated with a clear emulsion), illuminate the object and reflect sunlight back to the plate (object beam). As the light waves move through the emulsion, they also act simultaneously as a reference beam (See Fig. 1.6).

Interference takes place between the reference beam incident on the emulsion and the light waves

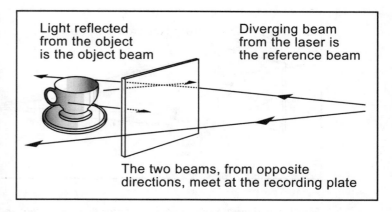

Fig. 1.6. Diagram of a simple reflection hologram recording setup.

reflected back to the emulsion from the object. The interferance produces a pattern that is recorded in the plate. This recording setup produces holograms called *reflection holograms*.

The term "reflection" refers to the way the hologram is illuminated when you want to view the holographic image. Essentially, the reconstructing light source (the sun or spot light) illuminates the processed hologram from same side of the plate that the viewer is on. The reconstructing light interacts with the hologram interference pattern and reflects light back to the viewer's eyes (thus the term reflection hologram). The holographic image is seen behind the plate at the same position the original object occupied during the recording. The hologram gives the effect of looking through a window.

For this process to work properly, it is essential that the reconstructing light source strikes the recording plate at the same angle the reference beam passed through the plate during the exposure process. In the Shoebox experiment described in this book you will be sending a reference beam into your recording plate during the exposure from the right side at a 45 degree angle. You must illuminate the finished hologram from the same direction and angle in order for an image to be seen.

It is easy to display a reflection holograms in the home or classroom. If it is illuminated correctly, and you are looking directly at the hologram, you will see a three dimensional image of the object. It may look reddish orange and a bit ghostly, but the image you will see is a three dimensional image of the object.

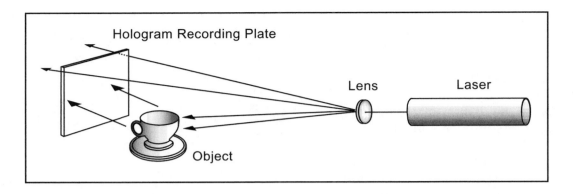

Fig. 1.7 A diagram of a simple transmission hologram recording setup. In practice the reference beam path (from the laser directly to the recording plate) would be extended by using a mirror in order to make the object and reference beam paths equal lengths.

Transmission Holograms

A different type of hologram, called a transmission hologram, can be made by using a different recording setup. Figure 1.7 shows a recording setup where both the object beam and reference beam strike the recording plate from the same side. Although the experiment in this book describes a way to make a simple reflection hologram, you have all the necessary components for making a simple transmission hologram.

Unlike reflection holograms, which are lit from the front during image playback, transmission holograms need to be lit from behind the recording plate (while a viewer looks at the plate from the front). As the reconstructing light passes (transmits) through the plate, the fringes in the interference pattern diffract the light into an image of the original object. The object is seen behind the hologram at the same position the original object occupied during the recording.

Transmission holograms reconstructed with laser light can produce very bright, distinct, 3D images that have considerable depth (up to a meter [or a yard] or more, depending on the size of the hologram and the type of laser used to make it), but they are rather difficult to display. If you hang one on a wall or stick one on the cover of a magazine, it can be impractical or impossible to position a laser beam behind the hologram. Therefore, one holographer developed a two-stage recording method for making transmission holograms that could be viewed without a laser. These rainbow-hued images could be illuminated with an ordinary spotlight or sunlight, but still had to be lit from the rear. One ingenious solution to this problem was to attach a mirror to the back of the trans-

mission hologram. Then it can be lit from the front. The illumination beam goes through the plate, hits the mirror and comes through the hologram from the back, thereby creating a viewable transmission image.

Mass Production

The holograms commonly attached to credit cards, concert tickets, packages and magazine covers are usually transmission holograms that have been coated with a mirrored backing. That is why they look silvery. These holograms are practical and affordable to mass-produce, so they are frequently used for high volume commercial applications. The interference pattern on the original hologram (the *master* hologram) can actually be stamped onto a thin piece of plastic by a high-speed mechanical press. This process is called *embossing,* and holograms produced in this fashion can be called *embossed holograms*. The embossed holograms are mirrorized on the rear surface and are typically glued to paper or plastic products. Small embossed holograms can cost less than a cent if produced in large quantities.

In contrast, reflection holograms are copied by optical processes. Mass production takes longer (each hologram has to be exposed), and the recording materials cost more. However, one photosensitive material, called photopolymer, has been developed especially for the mass production of reflection holograms. It is a plastic material that reacts to laser light. Since it contains no silver halide compounds, it is much cheaper to manufacture than the recording plates you will use here. In addition, it can be processed without chemicals. Unfortunately for hobbyists on a budget, the material is not very photosensitive.

Holographers need to use powerful, relatively expensive lasers to expose it, or else they need to make very long exposures. You may see more of this type of hologram in the near future, as some factories are starting to produce photopolymer holograms with realistically colored 3D images.

Preventing Motion

Holographers avoid making long exposures. Making a good interference pattern requires that the reference beam and object beam interact at the recording plate and remain motionless relative to each other during the entire exposure time. If one of the two beams wavers, or the recording plate moves the tiniest bit during the exposure, a good interference pattern will not be recorded. A "tiny bit" means a fraction of a wavelength of light. The faster the exposure, the less chance anything has to move while the interference pattern is being recorded.

To combat unwanted motion, holographers do several things. One, they use an object that is solid and completely stable. Objects made from metal, glass, ceramic, porcelain and stone are good. Objects made from flimsy materials (cloth, feathers, paper, plants) are not. If the object has any moving parts, the parts must be glued or otherwise immobilized. Many times companies that want to make high-quality holographic images will commission a sculptor to carve detailed, stable models of objects that are impractical to record otherwise.

Certain lasers can be used to make holograms of living things, such as people, animals and plants. These lasers, called *pulsed lasers*, emit a powerful burst of light so quickly (in a few billionths

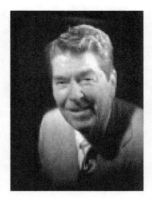

Fig .1.8. A photograph of the first and only Presidential portrait hologram.

Former President Ronald Reagan posed for a holographic portrait at the Brooks Institute of Photography in 1991. The finished hologram prints are in the collection of the National Portrait Gallery and the Ronald Reagan Library.

of a second) that the object doesn't even have time to move during the exposure. These lasers are quite expensive (tens of thousands of dollars) and require training to operate, as they are potentially dangerous. However, holographic portraits of people are quite fascinating. (See figure 1.8.)

Another way to prevent unwanted motion during exposure is to isolate the recording setup from the surrounding environment. Many vibrations too small for you to feel are constantly passing through the ground. They can be induced by passing automobiles, footsteps or any other activity occurring near your house or classroom. If these vibrations shake the object or recording plate during exposure, the movement will ruin the hologram. Therefore, holographers often make *vibration isolation tables* on which to set all or some of the components. This book provides instructions for building a small table to hold your object and your recording plate. (See figure 1.9.) The table is so massive that it is difficult to vibrate. The tabletop also floats on a cushion of foamlike material, so any additional vibrations are absorbed.

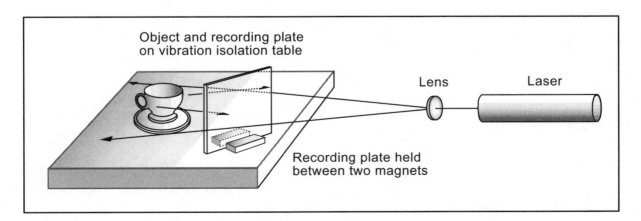

Fig. 1.9. The Shoebox Holography hologram recording setup used to create a simple reflection hologram.

Conclusion

You are advised to read the entire book before starting the Shoebox Holography experiment. If you understand the principles at work and you follow the directions provided, you will make a nice hologram. Illuminate it correctly and you will see a fascinating three dimensional holographic image!

Chapter 2

A Brief History

This chapter provides a historical overview of the field of holography. Major technological developments and commercial applications are discussed.

Gabor's New Idea

Hungarian physicist Dennis Gabor is credited with conceiving the theory of holography while working at a British laboratory in 1947. His research team was trying to improve the resolution of images produced by a device called an electron microscope. This device used beams of electrons to examine the structure of very tiny objects – such as the molecules in crystals.

Gabor proposed a new way to record and magnify the poor quality images produced by the electron microscope. His method was based on exploiting the similarities between electron beams (which are too small to see) and beams of visible light (which are more practical to work with). Both types of beams exhibit wavelike characteristics, an optical property that became the foundation of Gabor's idea.

Gabor developed a two-part imaging method comprised of an image recording process and an image reconstruction process. He was the first to successfully demonstrate this new imaging method, though the ramifications of his work would not be realized fully until others refined his techniques. At the time his ideas were published (1948 and 1949), their practical applications could only be imagined. (See figure 2.1.)

Gabor's image recording process utilized three basic components: the object being studied, an appropriate beam source (used to illuminate the object), and a recording material (used to capture the image). For his landmark experiments, Gabor utilized a tiny piece of clear film (a transparency) with writing on it as an object, a mercury-arc lamp as a beam source (it had the necessary optical properties) and glass plate coated with photosensitive emulsion as his recording material.

Somewhat like the photographic process, Gabor used a beam of light from the lamp to illuminate the object. This was called the *object beam*. During the exposure period, lightwaves reflected off the object and onto the recording material (film). Unlike photography, while this was happening, Gabor simultaneously exposed the recording material with a second beam of light, identical to the first except that it did not illuminate the object. This was called the *reference beam*.

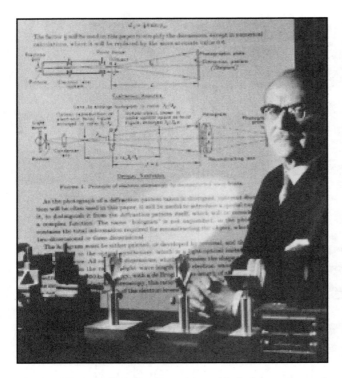

Fig. 2.1. Dennis Gabor poses next to his hologram recording setup and his landmark paper that explains the "principles of electron microscopy by wavefront reconstruction."

Gabor arranged the recording setup so that some of the light waves emitted from the mercury arc lamp were distorted by the inscriptions on the transparency on their way to the recording plate. This was his object beam. The lamp light that traveled directly to the recording plate as it passed through the clear parts of the transparency acted as his reference beam.

The interaction of these two beams – one a simple, undisturbed reference beam, and one a distorted, more complex, object beam – created a unique pattern in the photosensitive emulsion during the exposure process. The pattern was created when the light waves in the reference beam collided and interacted, or "interfered with," the light waves in the object beam. Such patterns are called *interference patterns*. Physicists that had studied the wavelike characteristics of light knew about interference patterns but Gabor was the first to record them in order to capture and recreate visual images. His recordings were named *holograms* by either Gabor or an associate.

After the recording plate was developed and processed, the hologram exhibited unique properties. Most notably, if the hologram was re-illuminated only by the reference beam, the interference pattern recorded on the plate would focus the incom-

ing light waves into a copy of the object beam. In other words, the hologram would reconstruct the light waves that originally reflected from the object to it. The reconstructed light waves formed an observable image of the object.

Recording and reconstructing light waves to make a viewable image had interesting and important ramifications beyond electron microscopy. Unfortunately, due to shortcomings with the available light sources and some very basic problems with his optical configuration, Gabor had difficulty demonstrating the full potential of his new imaging method. He only managed to produce very small, blurry, flat images of the object he had recorded. His results were unimpressive to anyone but fellow physicists.

However, Gabor had demonstrated to the world that there was another way to capture and produce visual images besides photography, cinema or television. Though it was not possible at the time, Gabor's new method could theoretically be used to make fully dimensional images using any energy source that traveled in waves – whether it was electrons, microwaves, x-rays, sound, or visible light. This made Gabor's theory even more significant than intended. In 1971, Gabor was awarded the Nobel Prize for his discovery.

Classified Research Projects

During the 1950s, the United States and the Soviet Union raced each other to gain technological superiority. Since Gabor's "wavefront reconstruction" theory had possible military applications (as a way to improve radar imagery), research related to holography was mainly confined to government laboratories. Most research was considered classified and few papers about the subject were published. In addition, since Gabor's method produced images that were barely recognizable, there was no interest in developing this rudimentary imaging system for commercial applications. Even Gabor went on to pursue new areas of research.

One pair of researchers working at the University of Michigan during the late 1950s and early 1960s did eventually pick up where Gabor left off. Emmett Leith and Juris Upatnieks became interested in Gabor's theory as a result of their work with radar imaging. They began to seek solutions to the problems inherent in Gabor's recording and reconstruction method in an attempt to improve the image quality.

First, Leith and Upatnieks rearranged the optical configuration that Gabor had originally designed in order to remove the overlapping images that Gabor's method created. Their "split beam" or "off-axis" technique made it much easier to see the resulting images.

Soon after, they began to employ the newly developed *continuous wave (CW) gas laser* as the light source in their experiments. This device, introduced in 1962, emitted a beam of light that was perfect for recording and re-illuminating holograms. Leith and Upatnieks had access to the earliest models and by 1963 they were making images using a helium-neon laser.

An article in the March 1964 issue of *Popular Mechanics* heralded this new "lensless photography technique," which employed a laser to record and project pictures, somewhat like a slide projector. However, the article only describes the system as a way to enlarge photographs or to improve x-rays.

By the time the article was published, Leith and Upatnieks had improved their laser-based hologram recording technique to the point that it could be used to create highly detailed three dimensional images of solid objects. Realistic-looking images with depth—unlike any photograph – could now be exhibited. This can be regarded as a revolutionary development in the history of imaging.

During that same time period, a Soviet researcher named Uri Denisyuk (inspired by a science fiction story he had read) was also investigating and refining Gabor's work. By rearranging Gabor's optical configuration in a different manner than Leith and Upatnieks did, Denisyuk developed a way to record and display striking three dimensional images. However, the Soviet achievements in holography were not well publicized in the worldwide scientific community.

Though a laser was still required to record the hologram, Denisyuk's method produced *reflection holograms* that could be viewed without using a laser. This was an important and practical development if holograms were ever going to be displayed outside the laboratory since lasers at that time were large, expensive and fragile. Reportedly, his techniques were used to make very realistic images of Soviet art treasures too delicate and rare to display to the public. Instead, the holographic duplicates were exhibited. His techniques also resulted in our Shoebox Holography experiment.

Corporate R&D

As lasers became more available in the mid-1960s, many large companies explored holography for a variety of possible commercial applications. Hundreds of papers relating to all aspects of holography were published. Optical engineers pursued research in computer-generated holography, full-color holography, information storage and corrective optics. In 1966, one company, Conductron Corporation, succeeded in producing life-size holographic portraits of people. IBM, TRW, Bell Labs and others investigated holographic movies. By 1969, RCA was experimenting with holographic television.

One scientist working for Polaroid Corporation, Steve Benton, introduced a very important variation to the hologram recording process in 1969. Benton's process involved making a second hologram from the first. The second hologram could then be viewed using a spotlight or sunlight. Though the resulting image had a rainbow hue and limited parallax (you couldn't see over or under the image), Benton's technique allowed holograms to be displayed easily outside the laboratory. In addition, the two-step production technique allowed additional visual effects to be incorporated into the final image during the copying step. Benton's "rainbow" method became a standard way of making holograms for display applications.

Other scientists realized that holographic interference patterns had another valuable characteristic. Besides the ability to regenerate three dimensional images, they could also be used to make very precise measurements. This optical effect, called *interferometry*, was extremely useful to engineers working in the aviation, automotive and defense industries. Using holographic interferometry, materials could be tested and evaluated for strength and durability in new ways. This technique was the most commercially utilized aspect of holography for years to come.

Clearly, the advent of the laser had spawned an exciting and promising new imaging technology – the field of holography. Researchers worldwide demonstrated many fascinating and useful optical effects but by the end of the decade few corporate managers believed that holograms were cost effective to produce for widespread commercial display applications. Lasers were still relatively expensive and recording materials scarce. But the few holograms that had been publicly exhibited had

ignited the interest of a new generation of holographers.

Technology and Art

By the early 1970s, a few visual artists had acquired permission to access corporate and academic holography laboratories. Working alongside the scientists, these technically minded artists explored the potential of this new imaging technology as a creative medium. Small communities of like-minded artists formed around the few existing holography studios. Due to budget constraints, ingenious production methods were developed that produced surprisingly successful and impressive results. Schools were established to pass on the knowledge gained. Graduates built their own studios, often with homemade and salvaged materials.

More and more art holograms and a small but growing number of commercial displays were starting to be produced by folks calling themselves holographers. Though high-budget corporate involvement with holographic imaging had stalled, it was replaced by a greater number of entrepreneurial businesses that sought to exploit the public's fascination with 3D images. Hologram production studios were established and customized holograms were made for clients who could afford them.

The promise of an emerging commercial imaging industry led a few other manufacturers to develop better recording materials and more affordable production equipment but most holography was still accomplished using technology borrowed from other industries.

However, based upon the growing number of popular gallery exhibitions and even celebrity interest, (such as artist Salvador Dali and '70s rock star Alice Cooper) holography was starting to be taken seriously as an emerging art form. (See figure 2.2.) By the end of the 1970s, a small but growing network of art galleries, museums and traveling exhibitions had sprung up across the world to showcase the work of these high-tech artists sculpting images with laser light. The public was typically enthralled with their work but holograms remained a fascinating visual novelty.

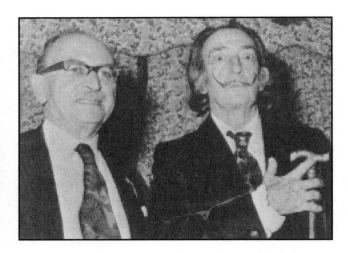

Fig. 2.2. Holography pioneer Dennis Gabor and surrealist painter Salvador Dali. Dali produced several artistic holograms in the 1970s.

Art and Business

During the 1980s holograms started to be used commercially in an increasing number of applications. This was mainly due to the fact that a few companies had figured out how to mass-produce holograms in a cost-effective manner. Most notably, a company called Light Impressions developed a commercially viable system to mechanically stamp holograms on inexpensive foils and plastic films. These *embossed holograms* could be easily attached to paper or plastic by gluing, hot stamping, or laminating.

Since making these embossed holograms required specialized equipment and knowledge, major credit card companies started to use them as a security device. By the mid 1980s, Visa and MasterCard were ordering millions of holograms. Other companies concerned with authentication soon followed suit. Gradually, many more embossed hologram origination facilities and production plants became established, typically staffed by former artists. As the technology progressed, other commercial applications were explored.

The cover of the March 1984 issue of *National Geographic* showcased how publications could be illustrated with relatively large embossed holograms. Two of its later covers also featured state-of-the-art holograms. Other publishers soon followed suit — holograms were used on a variety of magazines, children's books and annual reports.

Advertisers and marketing departments soon realized that the rainbow-colored effects produced by embossed holograms attracted attention to their

products. Most importantly, attaching holograms to a product increased sales and decreased counterfeiting. Soon embossed holograms appeared on book jackets, merchandise tags and product packaging. Decals and labels, (and eventually postage stamps and currency) with embossed holographic images became a familiar sight.

Other types of holograms were also being mass-produced for commercial applications. Some companies incorporated holograms into jewelry. Others produced 3D pictures for sale in museum gift shops and hologram specialty shops. Products decorated with holographic materials became a common sight at the local mall. Large, realistic-looking holograms started to appear at trade shows and in corporate lobbies. The term *hologram* started to be heard and recognized more, though science fiction movies, television shows and stories falsely depicted holograms as being projections floating in mid air.

At the grass-roots level, Ross Books published the *Holography Handbook — Making Holograms the Easy Way* (Unterseher, Hansen and Schlesinger 1982). This landmark how-to text taught people how to make high quality holograms using readily obtainable materials. Public schools and universities starting offering holography courses. A number of hobbyists set up their own holography studios and produced art for exhibition and sale. Collectors started to purchase holographic art for hundreds or even thousands of dollars. Public exhibitions of both artistic and commercial holograms were well attended.

Industrial applications were also pursued. Specialized holograms, called *holographic optical elements (HOEs)*, were made that acted like glass lenses or mirrors but weighed much less. These HOEs were incorporated in a variety of optical devices, including supermarket bar code scanners and "heads-up" visual displays for aircraft and automobiles. These heads-up systems use holograms to create semitransparent readings on the windshield so that the pilot or driver doesn't have to look down at the instrument panel. Interferometry became a standard measuring technique. Computer companies even researched holographic memory storage.

By 1989, an industry consisting of scientific, artistic and commercial endeavors had developed to the point that Ross Books could publish a business directory, the *Holography MarketPlace*, that contained the names of hundreds of holography related companies.

High-volume Applications

Throughout the 1990s, holograms became an even more familiar sight in the marketplace. Big corporations developed their own in-house origination and production facilities and offered A–Z service, from image design to finished product. "Professional holographer" became a job title. These artists/optical engineers continually developed ways to make bigger and more colorful holograms for the packaging and decorative industries and more complex ones for security applications. They developed ways to incorporate motion and color into their images. Computers and digital images were integrated into the manufacturing process. Automated manufacturing processes were introduced and refined.

Mass production methods became more efficient and cost effective. Unit costs dropped to cents per square inch, or less, depending on the volume ordered. As the hologram manufacturing process was integrated into conventional assembly lines, holograms appeared on cartons of soda, boxes of toothpaste, trading cards, video movie boxes, concert tickets, CDs and driver's licenses. By the end of the decade, the holography business was generating tens of millions of dollars annually, or even more by some estimates.

Some Modern Commercial Applications

As holography has moved from the research laboratory to the factory, holography technologies have been adapted to a variety of existing industries. In addition, many new applications of the technology have been developed. Today, holograms are commonly found in the places we live, work and shop. Following are some modern commercial applications.

Holographic Optical Elements (HOE)

One attribute of holograms is that they can direct light in a desired path. In addition, it is possible to make a flat HOE on lightweight plastic that duplicates the optical properties of conventional optics. These holograms are much less expensive to manufacture and service than their glass counterparts.

Therefore, industrial designers, especially in the communications and air and space industries, are using HOEs to replace bulky and breakable optical devices (such as glass lenses and mirrors) in a wide range of industrial and consumer products. They are now being used to enhance the viewability of LCD screens, watch faces and other displays. HOE solar collectors are being researched, as well as high-speed optical switches for the fiber optics industry.

Security/Authentication

Holograms are difficult to produce and/or duplicate by the average criminal and therefore have become integrated into many government and commercial security programs. They have been attached to official documents, currency, tax stamps, event tickets, ID cards, credit cards and product labels. To further deter professional counterfeiters, hologram manufacturers have added sequential numbering, tamper-evident materials, and other covert features to their security holograms.

Packaging

Attracting attention is the name of the game and holograms and holographic materials help differentiate one product on the shelf from another. The unique dimensional images and/or colors inherent to the medium catch a shopper's eye. Billions of square inches of holograms have been generated for this purpose. Many packaging companies (especially those associated with the labeling and hot-stamping industries) have successfully integrated holographic materials into their existing production lines. It is common to see holographic designs on foil wrapping, plastic films, cardboard containers, and other paper products. Holograms are often combined with more traditional printing methods to achieve the best effect.

Advertising/Promotion

In a world swamped by merchandise displays and marketing gimmicks, holograms still attract attention long enough to convey a message — which is the goal of any advertiser. Holograms have been used in a variety of promotional campaigns, including direct-mail, point of purchase, and even billboards. They have appeared on flyers, posters, magazine inserts, ad premiums, T-shirts, and executive gifts. Ad-industry trade journals have repeatedly reported successful and measurable results from companies using holograms in their advertising programs.

Value-added Decoration

Textiles, paper products and even candy have been embellished with holograms. Many companies use holograms to spruce up their stationery, annual reports and product catalogs. Others decorate their products with attractive holographic materials. Still others produce actual holograms to increase the value of items, such as collectible trading cards and figurines. One of the fastest growing applications is in the fashion industry.

Signs

From indoor point-of-purchase displays to roadside billboards, holograms of all sizes and types are being used to deliver information to the viewer. Fully dimensional pictures, animated holographic images, and holographic portraiture are being employed to complement, and even replace, printed signs, photographs, and transparencies. A major automotive manufacturer has recently announced the production of a full-color hologram measuring 40 square feet!

Illustration and Educational Displays

By providing dimensional information on a flat surface, holograms can illustrate books, catalogs and magazines in new ways. Although the educational uses have been mainly limited to children's books, the potential exists for instructional applications in medical, scientific and industrial publications. One group has recently developed a way for doctors to use three demensional holographic imigaes of X-rays to help diagnose their patients.

Giftware

Over the past decade, a sizable retail market has been developed for hologram pictures, such as wall decor, jewelry, watches and related optical novelties. Once confined to museum shops and specialty stores, holograms have now become mainstream. Although the sales boom may have slowed as the initial novelty wore off, unique hologram products are constantly being introduced, as the giftware industry requires new merchandise each year.

Trade Show, Museum and Lobby Displays

Over the years, numerous holograms have been produced for corporate clients and museum exhibitions. They are usually required to be large, measuring several square feet or more. When properly displayed, the effects are indeed remarkable.

Images can project up to several feet in front of, and behind, the hologram. Fully detailed, multicolor images can be produced. Animated effects are possible as well.

Since holograms capture microscopic details, museums have recorded archival images to exhibit in place of the actual objects, which are safely stored away. Objects too impractical or too heavy to move (like industrial equipment) can be recorded on a hologram, rolled up in a tube, and displayed in full detail at the next trade show.

Art

Some of the most distinctive and spellbinding art in the past thirty years has been produced by holographers. Still in its infancy compared to photography, and seemingly surpassed by the proliferation of digital technologies, holography still can do things other media can not. As the technology becomes even more accessible, more artists may start utilizing the unique attributes of holography to express their ideas.

Science and Research

Physicists use holography to record the interactions of sub-atomic particles. Optical engineers use holography to make minute measurements. Biologists use holography to study cells and tissue. Mechanical engineers have used holographic interferometry for decades to test for stress and faults in materials. In addition to photonic applications, there is a related field of acoustic holography (very useful to those developing surround-sound systems).

Future Trends

Fifty years after Gabor's initial work, three recent developments will take holography into the next century. The first is the introduction of a full-color holographic recording material by DuPont that can record very realistic images. The material is a special formulated plastic film that can be developed using heat and light. A few billboard-sized holograms have already been produced using this material. One company, Dai Nippon Printing Company of Japan, has already developed a way to mass-produce these color holograms. One of the very first of this type produced is showcased on the cover of the *Holography MarketPlace, 8th Edition*.

The second is the development of a camera/holography printer system by Sony Corporation that can make 3D images from a digitized source in a few minutes. Using this technology, holograms can be produced almost anywhere the camera can be set up. A few seconds of motion can even be recorded and displayed. Or if the hologram printer is connected to a computer graphics workstation, we may see a desktop printer capable of making three dimensional images.

The third, and most important to you, is the introduction of inexpensive semiconductor diode lasers. Until recently, all holograms had been made using relatively expensive lasers. Powerful pulsed lasers typically cost a hundred thousand dollars or more. Other commercial lasers can cost tens of thousands. Even a low-powered laser suitable for hobbyists or students typically costs at least a few hundred dollars. Not any more.

Now, as this book will demonstrate, it is possible to make high quality holograms with easily obtainable materials, including the laser found in ordinary laser pointers. These are commonly available for less than $20.

Higher-powered diode laser systems, suitable for more advanced work, are available for those of you who choose to continue your involvement with holography. These lasers, also quite affordable, are capable of producing larger and more complex three dimensional images. With the advent of green and blue diode laser sources and improved recording materials, the development of an affordable and practical full-color hologram recording system is just around the corner. Imagine being able to make realistically colored, fully dimensional images in your own studio or classroom.

A new generation of holographers is now being created. As this book demonstrates, the future of holography is you!

Frequency Hz	Type of Radiation	Wavelength Cm	
10^{23}			
	Cosmic Rays	10^{-12}	
10^{22}			
		10^{-11}	
10^{21}			
	Gamma Rays	10^{-10}	
10^{20}			
		10^{-9}	
10^{19}			
	X-Rays	10^{-8}	
10^{18}			
		10^{-7}	
10^{17}			
		10^{-6}	
10^{16}	Ultraviolet Radiation		
		10^{-5}	
10^{15}	Visible Light		
		10^{-4}	
10^{14}			
	Infrared Radiation	10^{-3}	
10^{13}			
		10^{-2}	
10^{12}	Submillimeter Waves		
		10^{-1}	
10^{11}			
		1.0	
10^{10}	Microwaves (Radar)		
		10	UHF
10^{9}			
		10^{2}	VHF
10^{8}	Television and FM Radio		
		10^{3}	HF
10^{7}	Short Wave		
		10^{4}	MF
10^{6}	AM Radio		
		10^{5}	LF
10^{5}			
	Maritime Communications	10^{6}	VLF
10^{4}			

The electromagnetic spectrum with indication of principal radiation categories.

Herz (Hz) is a unit of frequency equal to one cycle per second.

Wavelength is the distance in the direction of progression of a wave from any one point to the next point of corresponding phase.

Chapter 3

Lasers

This chapter discusses the basic physical principles behind laser theory and explains what types of lasers are used to make holograms.

Basic Physics

To sufficiently understand the operation of lasers, their many advantages and their necessity in the production of holograms, one must first comprehend certain basic properties of our physical world.

Matter and Energy

The entire universe consists of only two things: *matter* and *energy*. Matter is all things that have physical substance; energy is the mover, or potential mover, of physical substance.

Matter is the stuff we see, smell and feel. It has mass and occupies space. Matter both possesses energy and is affected by it. If matter had no energy, it would be reduced to a dark, frozen lump.

Energy, on the other hand, is less tangible. It is the driving force behind all forms of motion: the motion of planets, the motion of our cars, the motion of atoms. Nothing moves without it.

Energy is formally defined as the ability to do work. Work is the mechanism that transfers energy through a system. Applying a force on an object such that motion occurs over a distance produces work. For example, when you pick up a book, you have performed work on the book. The heavier the book, the greater the force that is necessary to raise it—therefore, the more work done. The farther you raise the book, the greater the distance in which the force must be applied.

Energy is measured in joules, in honor of the British scientist James Joule. One joule is roughly the amount of energy required to lift an apple from your kneecap over your head. A gallon of gasoline has over 200 million joules of energy. Since the energy is not released until the gasoline is vaporized and ignited, it is more correct to say that the gallon of gas has that much *potential energy* (stored energy).

The law of *conservation of energy*, one of the most important laws of nature, dictates that energy is never created or destroyed; it can only be transferred to another object or converted into a different form of energy. No matter how many times it transfers or transforms, the amount of energy involved in any given transaction *never* changes.

In essence, a laser is a device designed to transform electrical energy into a corresponding amount of light energy. The process will be explained in more detail later in this chapter. Though they are not 100% efficient in this conversion, lasers are still an extremely useful tool, especially for holographers, since holograms are made with the type of light that lasers produce.

Potential Energy and Kinetic Energy

There are several types of potential energy and various ways it is stored until it is used to perform useful work. There is gravitational potential energy (water behind a dam), mechanical potential energy (a coiled spring), electrical potential energy (a battery), chemical potential energy (gasoline, food), and nuclear potential energy (an atomic bomb). These stored energies are commonly transformed into electricity, which is used to power, or move, machinery: i.e., perform work.

The energy associated with moving objects is called *kinetic energy*. All objects in motion possess it. An object will gain kinetic energy when work is done to it and will lose kinetic energy when work is done against it. The amount of kinetic energy an object gains or loses is exactly the same as the amount of work done on or against it.

For instance, if you a roll a ball across the floor, it will travel in exact accordance with how much energy you supplied, minus the effects of friction. Friction creates heat, which is one type of kinetic energy generated by the motion of molecules. (The faster molecules move, the more heat generated. That is why boiling water is very hot and frozen water is not.) Remember, the amount of energy involved in the whole process never changes, it is just transformed from one type of energy to another. Some types, like heat, are just easier to identify and measure than others.

Sound is another form of easily recognized kinetic energy that occurs when a disturbance in a medium (commonly air) causes molecules to move back and forth (vibrate), which in turn creates "sound waves." Eventually, the sound waves hit an eardrum, causing it to vibrate. The vibrating eardrum sends signals to the brain that enable us to "hear" the sound energy.

Electromagnetic Radiation

One of the most important forms of motion energy is *electromagnetic radiation*. It exists everywhere throughout the universe and comes in many forms: radio and television waves, microwaves, infrared radiation, visible light (the only form of electromagnetic radiation that we can see unaided), ultraviolet radiation and x-rays. Although we perceive and apply them differently, all forms of electromagnetic radiation are essentially the same phenomenon. Only the amount of energy per fundamental unit distinguishes a microwave from a beam of light.

The fundamental unit of electromagnetic radiation is called the *photon*, an infinitesimally small "packet" of energy that has zero mass, and no electric charge. As a photon travels through space, its energy varies in intensity in a cyclic pattern. A drawing of these changes over time would produce a wavelike form.

Radio waves have relatively low energy per photon. Microwaves have more energy per photon than radio waves but not as much as infrared radiation. A photon of visible light has more energy than a photon of infrared radiation but less than ultraviolet radiation. X-rays and gamma rays carry the most energy of all. We can order these energies in a continuous array called the electromagnetic spectrum. See page 32.

Electromagnetic radiation is created by accelerating or decelerating an electric charge. The greater the acceleration or deceleration of an electric charge, the more energy it will produce. Electric charges that are stationary, or those moving at a constant velocity, do not create electromagnetic radiation.

An electron, the most fundamental unit of negative charge, is the most common vehicle for creating different types of electromagnetic radiation. It is a stable sub-atomic particle with an extremely tiny mass (9.1066×10^{-28} grams).

For instance, electrons moving up and down an antenna produce radio waves. Electron activity in atoms can produce another form of electromagnetic radiation that we find extremely useful—visible light. As explained later, this activity is the basis on which lasers are created.

Wavelike Properties of Electromagnetic Radiation

Experiments performed in the 1800s demonstrated that light (one form of electromagnetic radiation) acted in a wavelike fashion, similar to the way that water acts in a pool. Water waves make a useful model for the study of electromagnetic waves because they are commonplace, exhibit comparable properties, and move slowly enough to be carefully observed. As with all models, though, it is only a useful comparison, as there are a few profound differences between the two: speed, dimension, orientation and the medium that they travel through.

Electromagnetic waves move extremely quickly; water waves move relatively slowly. In empty space, electromagnetic waves move at a velocity of 300 million meters per second (186,000 miles per second). Known as the speed of light, it is abbreviated in equations with the letter "c". In his 1905 paper on special relativity, Albert Einstein correctly defined the speed of light as the absolute fastest velocity possible — a cosmic speed limit, so to speak. In air, the velocity of light is just slightly less than "c" (though it is acceptable to use "c" in most equations). Light traveling through water is even slower, but still magnitudes faster than water waves themselves travel.

Water waves propagate in two dimensions on a plane (i.e., on the surface of a pool). Electromagnetic waves tend to propagate in three dimensions (imagine an expanding, rippled balloon growing ever larger from a central point). A laser is designed to channel waves such that their propagation is substantially in one direction. This unidirectional propagation of electromagnetic radiation is generally referred to as a *laser beam*.

Electromagnetic waves can be spatially oriented any number of ways. If all the waves are arranged so that they are oriented the same, we say that the waves are polarized. The human eye is not sensitive to polarization and cannot distinguish between polarized or unpolarized light waves. In holography, where consistency of the source's waves is critical, polarization is an important optical characteristic to utilize.

Finally, water waves must propagate in a medium (water). Electromagnetic waves need not. They can travel through empty space.

Waves in a Pool – An Analogy

A wave is created by a disturbance. For instance, in a swimming pool, if a swimmer slaps his hand on the water, the disturbance creates a wave that moves from one end of the pool to the other. The wave has a "crest" (high point) and a "trough" (low point). A closer look at the wave would reveal that the water molecules do not travel with the wave. One may ask, "If the water molecules aren't moving in the direction of the wave, what is?" The answer is energy.

If the swimmer slaps his hand many times in regular intervals, a wave with a series of crests and troughs is created. Each pair of one crest and one trough is called a cycle (see figure 3.1) due to its tendency to repeat. If the intervals are fast, the crests and troughs (or cycles) will appear to be closer together. An observer sitting by the pool could count the number of cycles that pass by each second. This value, the number of cycles per second, is called the frequency (for space economy, we use the letter "f" in equations) of a wave. The unit of one cycle per second is more commonly called a hertz (abbreviated Hz) in commemoration of the German physicist Heinrich Hertz. Because the frequencies of electromagnetic waves are quite high, larger units such as megahertz (one million hertz, abbreviated MHz) and gigahertz (one billion hertz, abbreviated GHz) are commonly used.

Fig 3.1. One cycle of a wave.

The velocity (v — measured in meters per second) of a wave is directly related to the medium in which the wave is traveling. If the pool was drained and filled with molasses, the velocity of the waves would be less than those moving in water. For the remainder of this section, it will be assumed that all waves generated in our fictitious pool are traveling at identical velocities.

The distance between two successive crests (or two troughs) on a wave is called the wavelength (λ), which is measured in meters or subunits of meters. (See figure 3.2.) The most common subunit for wavelength measurement of electromagnetic waves is the nanometer (nm) which is one-billionth (1×10^{-9}) of a meter.

Fig. 3.2. The distance between two successive crests (or troughs) on a wave is called the wavelength (λ).

When the swimmer slaps the water with slow intervals, the distances between the crests and troughs of the waves are large, hence the wavelength is long. The observer times very long cycles per second on such waves. The frequency is small. However, when the swimmer rapidly slaps the water, the crest and troughs seem to bunch together. The wavelengths are short. The observer counts many cycles per second. Waves with higher frequencies, therefore, have shorter wavelengths and waves with lower frequencies have longer wavelengths. The relationship between the two can be summarized in the equation:

$$f = v/\lambda \text{ or } \lambda = v/f$$

It is important to remember that, as long as you adjust their numerical values per the above equation, frequency and wavelength are interchangeable. In the study of light it is common to use either term.

The swimmer may also notice that when he slaps the water with more force, the crests become taller and the troughs become deeper. The height of the crests (or in many cases, the depth of the trough) is called the amplitude of the wave. If the swimmer continues producing waves, one long, unbroken string of crests and troughs will span the entire length of the pool. This is called *continuous wave transmission* (often called just CW transmission).

But, the swimmer could decide to produce one wave, rest (thus saving his energy), and then produce another wave — followed by another rest period. By saving his energy between waves, the swimmer could slap the water harder and produce waves of greater amplitude. This is called *pulse transmission*. Lasers are either continuous wave or pulse. Some applications require one type laser be used, some, the other type.

Wave Interactions

When sets of waves meet, they join together, and this phenomenon is called *interference*. How they interfere depends on to what degree the two waves are in or out of *phase* (called their phase relationship). Being in phase or out of phase refers to a comparison of two waves at a given point. If the crests and troughs of one set of waves coincide with the crests and troughs of another, those waves are said to be in phase. If a wave "A" and a wave "B" are in phase, the crests of the two waves will meet and combine to form one large crest for each cycle whose amplitude is the sum of the two individual crests. The troughs of wave "A" and wave "B" would also combine to form one large trough in each cycle whose amplitude is the sum of the two individual troughs. This is called *constructive interference*. (See figure 3.3.)

If the two waves are 180° out of phase, the crests of wave A would merge with the troughs of wave B (and vice versa), canceling each other's amplitudes. The result is a combined wave with little or no amplitude. This is called *destructive interference*. (See figure 3.4.) Sound engineers working the PA systems at concerts have to be very conscious of phase relationships. The incorrect place-

Fig. 3.3. Constructive interference of two waves in phase.

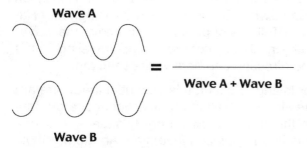

Fig. 3.4. Destructive interference of two waves out of phase.

ment of speakers could cause destructive interference between the sound waves and the audience might not be able to hear the music.

Because the phase relationship of two waves can change from one point to another, the two waves can be in phase when they pass the observer, but out of phase when they hit the far end of the pool. The ability of the two waves to stay in phase while they travel the length of the pool is called coherence. Waves that stay in phase for a long time are said to be very coherent.

Suppose two swimmers agreed to create continual constructive interference at one end of the pool. They would start slapping the pool at the same time while trying to maintain exactly the same frequency. If both swimmers have extremely good timing, they can keep the two waves coherent for a long period. But the swimmers, like other producers of waves (lasers, for example), aren't perfect. Their frequency may be slightly off.

The difference in frequency of any source (source is a common term for a device or system that produces waves) is called its bandwidth (abbreviated **f**, and measured in hertz). The coherence of a source can be determined by measuring how long the waves stay in phase. Be it a swimmer slapping the water or a laser, the distance that the source can guarantee the waves will stay in phase

is called its coherence length (L—it is measured in meters or subunits of meters). The coherence length of a source is of great importance to holographers. It is directly related to bandwidth by the equation:

$$L = v/\Delta f$$

Lasers are used to produce holograms primarily because no other source offers enough coherence.

Particle Properties of Electromagnetic Radiation

On October 19, 1900, Max Planck introduced a concept that was to revolutionize science. In an effort to resolve conflicts between scientific theory and experimental evidence, Planck suggested that energy (abbreviated in equations with the letter 'E') does not travel in waves but instead comes in discrete little "packets" called quanta. Although the mathematics seemed to work, and it did resolve conflicts between theory and experimental data, the implications of Planck's hypothesis were rather hard to accept. Clearly, light exhibited wave properties such as diffraction (bending around a corner), interference and polarization. Waves are inherently continuous and not discrete. How could light possibly consist of particles and demonstrate properties of waves?

The numerous experiments and the profound mathematics that followed are extremely significant. The final result of two decades of scientific fervor was a new definition of the laws of physics now known as quantum mechanics.

Quantum Mechanics and Photons

At the core of quantum theory is the concept of duality, which states that light, all other types of electromagnetic radiation, all other types of energy, and even matter are both waves and particles. Electromagnetic radiation itself is composed of minute "wave packets" called photons that demonstrate properties of both continuous waves and discrete particles.

One can classify all forms of electromagnetic radiation by the wavelength (or frequency) of the photon. Because the wavelength involved in the common forms of electromagnetic radiation is small, it is usually measured in nanometers. A nanom-

eter is a billionth of a meter. In visible light, the wavelength of a photon determines its color. Red has the longest wavelength (740–622 nm), followed by orange, yellow, green (577–490 nm), blue (489–430 nm), and violet (429–390 nm). White light is a mixture of all colors.

Photons with wavelengths longer than 740 nm produce low frequency radio waves and infrared (below red) radiation. Photons with wavelengths shorter than 390 nm create high frequency ultraviolet (beyond violet) radiation and x-rays.

In an atom, electrons reside in various positions and energy states around the nucleus. They can be imagined traveling in a series of successive orbits or "shells." If the atom is stable, the electrons are defined as being in their ground (lowest level of energy) state. When external energy is transferred to the atom, the electrons get "excited" and respond by jumping up to higher, or excited, energy states (to an outer shell).

Quantum mechanics dictate that an electron cannot reside between two energy states. It has to jump up all the way to a higher state or not jump at all. The electron will stay in the excited state for a very short period and then spontaneously drop back down to a lower energy state.

When the electron drops one or more energy "steps" it releases the amount of energy difference between the two states in the form of a photon. The wavelength of the photon is determined by the amount of energy released — the energy difference of the two energy states. If the energy released is small, the wavelength of the photon will be large and vice versa. This process is called spontaneous emission. In essence, photons can be created by transferring energy to an atom.

Laser Fundamentals

Albert Einstein was the first to recognize the significance of Planck's concept of quantized energy. In 1916, Einstein predicted a phenomenon now known as stimulated emission — the basis for all laser technology. (The same year, Einstein also released his most prized work, the general theory of relativity. The theory of stimulated emission went unnoticed until the late 1940s.)

In brief, Einstein theorized that if one photon passes closely by an excited atom it will stimulate that atom to emit a photon with the same exact characteristics as the first. Both photons will have the same wavelength (and therefore the same frequency) and will be in phase, coherent, and traveling in the same direction.

In an environment with many identical excited atoms, photons can multiply rapidly through stimulated emission. Two photons quickly become four which quickly become eight. Since atoms and photons are extremely small, eight photons can become billions in a reasonably short distance. This process of multiplying photons is called amplification; it is the essence of a laser. The term *LASER* itself is an acronym for *Light Amplification by Stimulated Emission of (electromagnetic) Radiation*. Billions of photons, with the same wavelength, in phase, coherent, and traveling in the same direction can be a very useful tool.

For lasing to occur, it is essential that there are more atoms with electrons in a higher energy state than those at the lower energy state — a condition called *population inversion*. An atom with its electrons in lower energy states will absorb a passing photon instead of duplicating it. If there is more absorption than stimulated emission, amplification will not occur. Having a population inversion ensures continuous multiplication of photons.

How Lasers Work

To create a laser, many atoms of one type must be contained in a given space. The atoms used for lasing are called the active medium. It is the active medium that determines the possible wavelengths produced by the laser. Solid state lasers have active media made from matter that is solid at room temperature. Neodymium and chromium ions (an ion is just an atom with either an excess or deficit of electrons) are common active media used in solid state lasers. Common active media used in gas lasers are neon, argon and ionized cadmium.

A pump is often needed to push energy into the active medium, raising the electrons to an excited (higher energy) state. Brisk and continuous pumping will create and maintain a population inversion. However, many active media are not efficient at receiving energy from the pump. In such cases, the active medium must be combined with another substance called a transfer medium. Common transfer media in solid state lasers are yttrium atrium garnet (YAG), yttrium lithium fluoride (YLF, pronounced "Yelf"), sapphire and ruby. Inert helium makes a good transfer medium and is used

in helium-neon (HeNe, pronounced Hee-Nee) and helium-cadmium (HeCd, pronounced Hee-Cad) gas lasers.

Continuous Wave Gas Lasers

Until recently, gas lasers have been the most widely manufactured type of laser. The gas is almost always contained in a long cylindrical tube. Tubes are made of various materials; ceramic and glass are the most common. Inside the tube is an equally long, yet very narrow (< 3 millimeters) bore that allows lasing to occur in a straight, usually horizontal path.

During lasing, a wide variety of spontaneous and stimulated emissions occurs throughout the tube, with photons propagating in every conceivable direction. Those photons traveling down the length of the bore continue to multiply through stimulated emission. By passing a number of photons with identical properties back and forth through the bore, it is possible to amplify them enough to create a visible beam. This is accomplished by placing mirrors on both ends of the bore. If both mirrors are 100% reflective, extremely high amplification is achieved but no photons can exit the laser. This, of course, has no value whatsoever. However, if one mirror is only partially reflective it will reflect most of the photons back into the bore while allowing a sufficient number to exit as a beam. Such a mirror found on lasers is called the output coupler, or OC. In most lasers output couplers allow 1-3% of the photons to be transmitted. (See figure 3.5.)

It is common to have multiple wavelengths lasing inside the cavity. In the same manner that the two swimmers discussed earlier produced slightly different wave frequencies, the lasing inside the cavity produces minute variations of photon frequencies (or wavelengths) in the beam that is defined as the laser's bandwidth (Δf).

The most dominant wavelength in a given laser is called the *primary wavelength*. Photons with undesirable wavelengths can be eliminated from the cavity by putting special thin film coatings on the mirrors. Such coatings only allow a specific range of wavelengths to reflect back into the cavity. Thus photons with undesirable wavelengths will not multiply and will not pass through the OC. Any light source that delivers exactly one wavelength is said to be *monochromatic*.

The power of a laser designates the amount of photons per second exiting the laser. Power is the amount of energy a source produces each second. It is measured in units of joules per second, more commonly called watts—in honor of the British scientist James Watt.

Primary Types of CW Lasers Used For Holography

The lasing process described above is continuous wave transmission. The four primary types of CW lasers commonly used in holography are HeCd, Argon-ion, Krypton-ion and HeNe lasers. Each has distinct advantages that are related to the holographer's needs. Typically, the type of recording material, size of the hologram, and operator's budget determines which laser is best suited for a certain application.

Helium-Cadmium (HeCd) Lasers

The active medium used in standard HeCd lasers is cadmium, which is abundant in nature. The stimulated emissions of cadmium provide a primary lasing wavelength of 441.6 nm, which is in the blue violet region of the visible spectrum. This wavelength is perfect for exposing the photoresist materials used to mass-produce embossed holograms. In addition to having the right beam characteristics for embossed holography, HeCd lasers are cost-effective to operate and relatively affordable. A high-powered HeCd laser with naturally occurring cadmium costs around $18,000. A typical HeCd laser tube lasts at least 4,000 hours.

Argon-Ion Lasers

Argon-ion lasers provide an attractive combination of high power and long coherence length (in most forms of holography, the coherence length of the laser determines the image depth

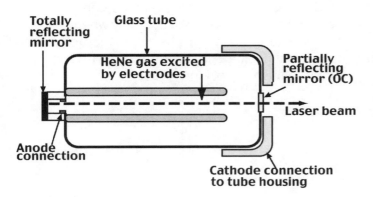

Fig. 3.5. A simple diagram of a HeNe gas laser.

of the hologram), enabling the creation of holograms that are both large and visually striking. They produce coherent light at a number of wavelengths, including 488 nm (blue) and 514.5 nm (green). Their power and output make them useful for exposing photopolymer films and some silver halide recording materials.

Although argon-ion lasers are capable of producing a significant amount of power, the energy efficiency of the laser is actually quite poor and a substantial amount of unwanted heat is created. To keep the temperature of the tube low enough to operate, large-frame ion lasers need to be cooled, usually with lots of circulating water. The price of a large-frame argon-ion laser with cooling devices generally starts at $30,000. In addition, the conditions inside an argon-ion laser tube are extremely harsh. Prudent operators can expect approximately 3,000 hours per tube.

Krypton-ion Lasers

Krypton-ion lasers create many wavelengths that are useful to holographers. Since red (647 nm), blue (476 nm) and green (521 nm) can be produced, in theory one laser could be used to make full color holograms on an appropriate recording material. However, Krypton-ion lasers are expensive to purchase and are often difficult to operate and maintain. They are mainly used in factories and laboratories.

Helium-Neon (HeNe) Lasers

The HeNe laser was the first gas laser to be commercially available, brought to market in 1963. (Select researchers may have had access to early models a year earlier.) Since the average HeNe laser costs between a few hundred and a few thousand dollars, performs well and is relatively small, it is the most commonly used laser for hobbyist and art holography, as well as for high-volume industrial uses. For instance, they are widely used in bar code scanners.

The active medium in an HeNe laser is neon. As in HeCd lasers, helium is the transfer medium. Most HeNe lasers are low-powered, typically delivering between 0.5 and 1 mW, at 632.8 nm. More expensive models are available, delivering up to 50 mW, at 632.8 nm. The beam is generally polarized with a coherence length between 20 and 30 cm. The average lifetime of an HeNe laser tube is about 15,000 hours. HeNe lasers emitting green, yellow, and orange wavelengths are also available, but their low power makes them ineffective in most commercial applications.

HeNe lasers are now being challenged by low-powered laser diodes that emit 635 thru 670 nm wavelengths. Laser diodes are extremely small, light, use very little current, need extremely low voltages, and are less than one hundreth the price of a comparable HeNe laser ($8 compared to $800 for a typical new 5 mW HeNe laser).

Pulse Lasers for Holography

There is another category of lasers worth mentioning as they are also used to make holograms. Instead of emitting a continuous beam, pulse lasers emit light in very short bursts, or pulses. These lasers can output enough light in a few billionths of a second to expose a hologram recording material. In contrast, CW lasers typically take seconds or minutes to make a similar exposure. Pulse lasers can in effect "freeze" motion similar to a strobe light.

In general, pulse lasers are required in order to make realistic-looking holograms of moving objects and living subjects (though some other methods have been invented). However, to get this much energy out of a laser in such a short time requires a lot of electrical power and complicated equipment. Pulse lasers generally require a trained and skilled operator. They are also rather expensive, ranging from $50,000 to $100,000 or more.

The first laser invented was a pulse laser based around an active medium of chromium. It was called a "ruby laser" because the chromium was mixed with aluminum oxide to produce a lasing material that had the characteristics of ruby. It also produced a deep red light. Ruby lasers operate at a wavelength of 694.3 nm.

Today, many holographers prefer using a pulse laser that emits green light, especially when shooting portraitures. Red light has a tendency to make human skin look rough; the green light makes for a more pleasant-looking subject.

Semiconductor Diode Lasers

The newest lasers to enter the market that are suitable for holography are tiny solid state CW lasers called semiconductor diode lasers. Semiconductor diode lasers are, as the name implies, lasers made from diodes fabricated from semiconducting materials. A diode is an electronic device with a positive and a negative end. Semiconducting materials let varying degrees of electrons flow through them, unlike conductors that let all the electrons through, or insulators that let no electrons pass. (For instance, copper is an extremely conductive material, so it is used for electrical wiring. Rubber is a good insulator, so it is used to shield you from getting shocked.) Diodes made using semiconducting materials have useful electrical and optical properties. They are also small, sturdy and cheap to produce.

Laser researchers have found that under certain conditions semiconductors made from compounds of a particular group of elements (specifically those listed in column III and column V of the Periodic Table) will emit light. The earliest and most basic diode lasers were made from special crystals composed of two slightly different types of gallium arsenide. Modern semiconductor diode lasers contain multiple layers of material of varying composition (the alloy aluminum gallium arsenide is commonly employed), but the fundamental characteristics of these enhanced materials are the same as the basic ones.

To make a simple diode laser, two semiconductor materials with different electrical properties are stacked together to make a single chip. This combined array is tiny; typically less than 1 mm in length. Most importantly, one of the semiconducting materials has "loose" or "extra" electrons (it is always labeled "n") and the other semiconductor material has "holes" where electrons are needed (it is labeled "p").

When an electrical current is applied to the semiconductor material with loose electrons, some break free and migrate to the "holes" in the other material. As the electrons cross the junction between the different materials (called the pn junction), photons are emitted. The thickness of the junction region is extremely small, about one micrometer, but it acts the same as a laser cavity in a conventional laser (which can measure several centimeters [or inches] to a meter [or several feet]). Waves of photons bounce between the flat, reflective parallel edges of the junction. A number of waves amplify themselves until they are strong enough to exit a small gap between the semiconductors. They exit as visible light. (See figure 3.6.) The light is very monochromatic and very coherent.

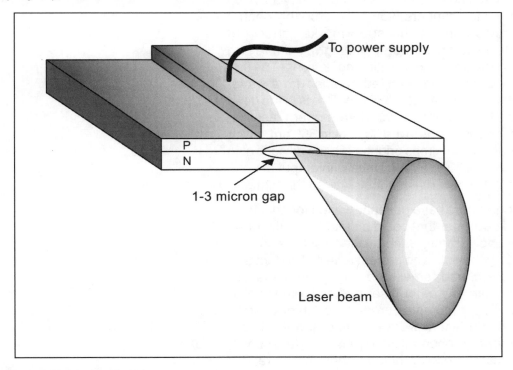

Fig. 3.6. A diagram of a semiconductor diode laser.

The light typically leaves the semiconductor diode through a rectangular gap, and diverges very quickly, which creates a wedge-shaped beam. The beam is said to be astigmatic. Usually, the laser manufacturer will place a specially shaped lens in front of the beam to create a tighter, rounder beam profile.

The laser diode itself is usually sealed in a sturdy housing to protect it. The housing also acts as a heat sink to drain excess heat away from the diode as high temperatures will damage the diode. The manufacturers will usually attach circuitry to power the diode correctly. Sometimes a very tiny light-sensitive device (called a photodiode) will be included in the circuitry to monitor and adjust the laser's performance.

Laser diode assemblies are most commonly found in audio CD players, video laser disc players and computer CD-ROM drives. Most of these devices produce a 3–5 mW infrared beam with a wavelength of 780 nanometers, which is almost invisible. Though the intensity of the laser beam is lower once it hits the disc, these laser diodes should be considered dangerous if they are ever removed from the players. The beam is hard to see and therefore hard to avoid. Looking directly into one can damage a person's eyes.

Laser diodes that produce visible beams are being manufactured more often now. They are used in bar code scanners (you have probably seen a thin red beam at the supermarket checkout counter), laser pointers, gunsights, surveying equipment and other positioning devices. The first visible laser diodes emitted beams with a wavelength of approximately 670 nm. This is in the deep red part of the spectrum. More modern laser diodes put out beams in the 635 nm to 650 nm, which looks about four times brighter. These devices also put out about 3 to 5 mW. Units with output of up to 50 mW are now making their way to the market.

Holographers have patiently waited for an affordable diode laser that could be used to make high-quality holograms. Such a laser would be invaluable to hobbyists and professionals. The fact that they are cheap, small and require less maintenance than any other laser makes them suitable for studio or automated production. Unfortunately, early diode lasers were unstable and the beam was not very coherent. However, when laser pointers became popular, holographers had a readily available source of affordable products to test. As this book demonstrates, some models of "red light" diode lasers, especially those that output in the 635–650 range, are very appropriate for use in a hologram recording system. Replacing a $1,000 dollar, three-foot-long fragile tube laser with a $10 pocket-size one is now achievable.

A few manufacturers do make laser diodes that emit green and blue light: however these are much more expensive to make than their red counterparts. (Green light is currently produced by manipulating [doubling] the shorter frequency of light emitted from an infrared diode). If these shorter wavelengths begin to be utilized more commercially (to encode more information in a given space on a CD, for instance) prices could drop significantly. Once they become less costly, and they are paired with a suitably sensitive recording material, full-color holograms could conceivably be produced automatically by desktop hologram machines hooked to a personal computer. Or by hobbyists and students working in their own holography studios and classrooms!

Preparing for the Experiment

Chapter 4

Equipment Checklist

This chapter provides a list of items needed to perform the Shoebox Holography experiment, as well as explaining when and how each item is used.

Items Available in Most Households

The items on this list can be collected easily around your house or in your classroom. If you are unable to find these items, you should be able to acquire them for very minimal expense at a local market or convenience store. Items marked with an asterisk are described in more detail in Chapter 5 along with some recommended suppliers.

Note: Metric measurements can be rounded to the nearest integer or the nearest standard measurement used by manufacturers.

Qty.	Item
	newspaper
	paper towels
	tape (electrical and double-sided)
1	bright point source of light (a lamp with a clear lightbulb, or a halogen spotlight, or a flashlight). Refer to Module 10 for further details.
1	cotton swab (for Module 1, Method 1 only)
1	disposable funnel
1	felt-tipped pen (or any quick drying, permanent marker)
1	light tight box (at least 7.62 cm [3 inches] by 7.62 cm [3 inches] by 5.08 cm [2 inches])
1	measuring cup that can hold 800 ml (approximately 27 fluid ounces, U.S.) of water
1	pair of scissors
1	plastic trash bag (with ties)
1	pot that can hold 800 ml (approximately 27 fluid ounces, U.S.) of water
1	shutter (a black cardboard card (20.32 cm [8 inches] by 25.40 cm [10 inches] or similarly sized box that will stand upright)
1	small knife (you can substitute scissors)
1	small object*
1	small, lint-free cloth or handkerchief
1	thermometer (capable of measuring 37.7 degrees Celsius [100 degrees Fahrenheit]
1	timer or watch that you can see in the dark (that can measure seconds and minutes)
1	way of heating water (stove, microwave, etc.)
1	white card (6.35 cm [2 ½ inch] by 6.35 [2 ½ inch])
1	wooden or plastic stick (for stirring)
1	meterstick, yardstick, tape measure or ruler
2	buckets (that can hold at least 3.78 liters [1 gallon U.S.] each)
3	empty plastic gallon "milk" jugs with screw-on lids
11.34	liters (3 gallons U.S.) of distilled water
1	Optional: hair dryer

Items Available At Most Hardware, Home & Garden and Electronics Stores

The items on this list can be purchased at very minimal expense from most hardware, home & garden and/or electronics stores. National chain stores such as Ace Hardware, Home Depot, Walmart and Radio Shack typically stock these items. Items marked with an asterisk are described in more detail in Chapter 5 along with some recommended suppliers.

Note: Metric measurements can be rounded to the nearest integer or the nearest standard measurement used by manufacturers.

Qty.	Item
1	laser pointer.* Note: this can also be ordered by mail or phone.
1	small can of flat black spraypaint
1	green filtered safelight* (a green phosphorus night-light works well)
1	"D" cell battery holder – holds 2 batteries (for Module 1, Methods 2 and 3)
2	"D" cell batteries (for Module 1, Methods 2 and 3)
2	insulated alligator clips (for Module 1, Method 2)
2	lengths of metal pipe (1.3 cm [1/2 inch] diameter, 20.32 cm [8 inches] long) threaded on at least one end
2	round metal flanges with flat base (7.62 cm [3 inch] diameter) that the pipe can screw into
2	spring clips (5.08 cm [2 inch] wide)
2	spring clips (2.54 cm [1 inch] wide)
2	clothespins
2	stone "patio" blocks or concrete slabs (approximately 20.32 cm [8 inches] square)
2	strong, rectangular magnets (approximately 2.54 cm [1 inch] by 1.27 cm [½ inch])
2	pairs of goggles
2	pairs of plastic gloves
2	aprons
2	dust masks
3	additional laser pointer batteries (for Module 1, Method 1 only)
3	large, disposable Styrofoam or plastic cups (or similar sturdy plastic containers) at least 7.62 cm (3 inches) wide
1	Optional, but highly recommended: steel or iron plate (approximately 20.32 cm [8 inches] square) with smooth surfaces.
1	Optional: piece of paper-thin rubber hose or thin plastic tubing (3.81 cm [1 ½ inches] in length and .95 cm [3/8 inch] in diameter) (for Module 1, Method 2 only)
2	Optional: pieces of thin, flexible, insulated copper wire or 2 lengths of wire that have pre-attached insulated alligator or insulated spring clips (each approximately 30 cm [12 inches] long) (for Module 1, Methods 2 and 3)

Items Available From A Specialized Supplier Or Hobby Shop

The items on this list can be ordered by mail or by phone from a specialized supplier and delivered to your door. You may be able to purchase or order them from a science supply store or hobby shop. Items marked with an asterisk are described in more detail in Chapter 5 along with some recommended suppliers.

Qty.	Item
1	lens*
1	package of hologram recording materials (6.35 cm [2 ½ inches] square glass plates)*
1	JD-2 hologram recording material developing and processing kit*
4	sorbothane vibration dampers*
1	Optional: pre-wired diode laser*

Items Available At Most Photo Supply Stores

Qty.	Item
1	Optional: small bottle of Photo-Flo™ 200 solution

Summary of Items and Their Usage

Qty.	Item	Refer to Module(s):	How is this item used?
	tape (electrical)	1, 2	to wrap electrical connections and magnets
	tape (double-sided)	1, 2	to stabilize holders if needed
1	cotton swab	1 - Method 1	to help remove pointer batteries from laser pointer
1	laser pointer	1, 2, 3, 6, 7	to expose recording plate
1	pre-wired diode laser*	1, 2, 3, 6, 7	pre-wired laser light source that can be substituted for laser pointer to expose recording plate
1	"D" cell battery holder	1 - Method 2, 3	to hold batteries for outboard power supply
2	insulated alligator clips	1 - Method 2	to connect battery holder wires to laser pointer
2	pieces of insulated wire	1 - Method 2, 3	extension wires to connect outboard power supply to laser pointer or to pre-wired laser diode

Qty.	Item	Refer to Module(s):	How is this item used?
2	"D" cell batteries	1 - Method 2, 3	for powering laser pointer or pre-wired diode laser when using outboard power supply
3	additional pointer batteries	1 - Method 1	provides extra power for laser pointer
1	rubber hose or tubing	1 - Method 2	to insert into laser pointer battery case to prevent accidental short circuits
1	steel or iron plate	2	adds weight to vibration isolation table, helps hold magnets
1	lens	2, 3, 6	spreads beam so it covers recording plate
1	lint-free cloth	2, 6	to hold and clean lens, to temporarily set the unexposed recording plate on
2	metal pipe, threaded end	2	pole for component holders
2	round metal flanges	2	base of component holders
2	spring clips (large)	2	to attach laser and lens to pole
2	spring clips (smaller)	2	to attach laser and lens to pole
2	stone "patio" blocks or concrete slabs	2	parts of vibration-isolation table
2	strong, rectangular magnets	2, 3, 6	to hold recording plate in place, to hold target card in place
2	clothespins	2, 8	to depress on/off switch, to hold recording plate during processing steps
4	sorbothane vibration dampers	2	to help isolate the object and recording plate from vibration
1	yardstick, tape measure or ruler	3	to measure distance from lens to recording plate
1	small object	3, 6	the thing you are making a holographic image of
1	shutter	3, 6, 7	prevents accidental exposure when recording plate is in place
1	white card	3, 6	a target for laser beam
	newspaper	4, 5, 8	to protect darkroom work area

Qty.	Item	Refer to Module(s):	How is this item used
	paper towels	4, 5, 8, 9	to clean up darkroom spills
1	funnel	4	for pouring powdered chemicals into mixing container
1	JD-2 processing kit	4	chemicals used to make developing and processing solutions
1	measuring cup	4	to measure water for chemical mix
1	scissors	4	to open plastic bags containing chemicals
1	thermometer	4	to measure temp. of warm water
1	water container	4	to heat water in
1	stove or microwave	4	warm water helps dissolve chemicals
1	felt-tipped marker pen	4, 7	to label containers and mark recording plate
2	aprons	4, 5, 8	darkroom safety equipment
1	plastic trash bag	4, 5, 8	for trash contaminated with chemicals
2	aprons	4, 5, 8	darkroom safety equipment
2	dust masks	4, 5, 8	darkroom safety equipment
2	pairs of goggles	4, 5, 8	darkroom safety equipment
2	pairs of plastic gloves	4, 5, 8	darkroom safety equipment
1	safelight	5, 6, 7, 8, 9	to light work area without exposing the recording plate
3	empty plastic gallon milk jugs	4	to hold chemical solutions
3	gallons of distilled water	4, 5	ingredient in chemical solutions and washes
1	wooden or plastic stick	5	to stir chemical solutions
1	timer or watch	5, 7, 8	to time exposure and processing steps
1	small bottle of Photo-FloTM	5, 8	prevents waterspots from forming on glass plates and photographs.

Chapter 5

Specs and Suppliers

This chapter provides detailed specifications about items needed for the Shoebox Holography experiment. Contact information for various suppliers is included.

General Information

Here is more detailed information about the major items needed to perform the experiment described in this book. You may be able to acquire some of these items from local outlets, especially the laser pointer and safelight. Product requirements are included if you choose to do so. However, you may want to order these items from a specialized supplier. Some manufacturers' and suppliers' names are provided below along with recent contact information and catalog product numbers. The companies listed have proven reliable and prompt, though we encourage you to find additional suppliers.

It is possible to find out more information regarding the equipment and supplies used to make holograms in the library and on the Internet. There are many books and web sites geared for holography students and hobbyists. One book in particular, *Holography Marketplace* is especially helpful. It is a regularly published holography sourcebook and reference text that includes an international listing of suppliers. In addition to general information about holography, it includes very specific information about lasers, recording ma-

terials and photochemistry. It can be ordered by contacting:

Ross Books
P.O. Box 4340, Berkeley, CA 94704
Phone: 1 (800) 367-0930
Phone: (510) 841-2474
Fax: (510) 841-2695
Web site: www.rossbooks.com

Laser Pointer

There are many laser pointers in the market today, ranging in price from a few dollars to hundreds of dollars. In many instances, with the more expensive models you are paying for the fancy casing or adjustable optics. (There are only a handful of diode laser manufacturers in the world, so many times the expensive pointer and the cheap pointer actually contain the same laser.)

For holography experiments you only need to be concerned about the type of diode laser that is inside the pointer. Fortunately, the simplest, most rugged (and often the least expensive) laser pointers work best for the experiment described in this book. (See figure 5.1.)

Requirements

Make sure the laser pointer you use has an output wavelength of red at 635 nm, 640 nm, or 650 nm. (660 nm and 670 nm pointers do not work as well.) "Apparent beam brightness" or beam distance is not a concern. Matching the hologram recording material's sensitivity range is. Presently, 650 nm diode lasers have the best price/performance ratio. The power output should be between 3 and 5 milliwatts. These lasers are classified as Class IIIa.

Recommendations and Suppliers

There are many laser pointer manufacturers. If you can't find a suitable laser pointer at your local hobby shop, electronics store or department store, try doing a search on the Internet for "laser pointer(s)," "laser(s)" and "holography" supplies.

We recommend using the Infiniter200 from Quarton, a major visible-laser, diode manufacturer. It has a suggested retail price of $14.95 (order #151-650200-AAB1) and can be ordered by contacting:

Quarton USA, Ltd. Co.
7042 Alamo Downs Parkway
Suite 370
San Antonio, Texas 78238
Phone: 1 800-520-8435
Phone: (210) 520-8430
Fax (210)520-8433
Web site: www.quarton.com

or Quarton Inc.
9F.,185, Sec.1, Ta-Tung Rd.
His-Chih, Taipei Hsien,
Taiwan, R.O.C.
Phone: (886-2) 2643-1000
Fax: (886-2) 2643-2000
Web site: www.quarton.com

Another laser pointer used to make holograms is called the Bullet Beam Laser Pointer (part number VEC150S) and it is made by VECTOR Manufacturing, Ltd. Reportedly, it can be purchased at many drugstores for $7.99. The mailing address for VECTOR is: VECTOR MANUFACTURING, Ltd.; 3003 Greene St.; Hollywood, FL 33020.

Fig. 5.1. A laser pointer on a keychain (above) and a pre-wired laser diode (below). Either unit can be used to make holograms using the Shoebox Holography method.

Fig 5.2. Another laser pointer that can be used to make holograms using the Shoebox Holography method.

Pre-wired Diode Laser

Many laser pointer manufacturers also sell pre-wired laser diodes that can be used to make holograms. These are referred to as "laser diode modules." The pre-wired laser diodes are sold without the pointer case or additional optics. These are very suitable for use by students or hobbyists. In fact, they may be considered even better to use, since those that come without pointer lenses emit a wider, more diffuse (and hence safer) beam. They also may be cheaper since you will only be paying for the laser diode assembly. Additional multi-unit discounts may be available to schools.

Requirements

A pre-wired laser diode needs to meet the same exact specifications as those listed for laser pointers (see preceding page). Order one with positive and negative leads pre-attached so it is easy to attach it to a power supply. (See figure 5.1.)

Recommendations and Suppliers

There are many laser diode manufacturers and distributors. Be aware that many manufacturers sell industrial and professional grade laser diodes with characteristics that exceed your needs. These are quite costly. The manufacturers usually sell a simpler, much less expensive counterpart.

Here is one example of a suitable unit listed in an optics catalog.

The LDLM200 SERIES laser module:

- Brass or Nickel-coated housing
- Wired Lead
- AlGaInP Semiconductor Laser Diode
- Vop: DC 3V, 4.5V, 6V
- Spot Size: less than 5 mm at 10 meters.
- Wavelength: 650 nm
- Output Power: 5 mW
- Weight: 8 g
- Dimension: L = 17 mm; Diameter = 8.0mm

Quarton USA, Ltd. Co. offers a pre-wired laser diode module, model number: LPA VLM-650004. Contact information is on the previous page. At the time this item was researched, it was "specially priced" in 50 unit lots for $150 ($3 each).

Laser Safety Box

Laser pointers and laser diodes are effective tools when used properly. The following considerations should be observed when using laser pointers:

- Never look directly into the laser beam.
- Never point a laser beam at a person.
- Do not aim the laser at reflective surfaces.
- Never view a laser pointer using an optical instrument, such as a binocular or a microscope.
- Do not allow children to use laser pointer unless supervised of an adult.

Only use laser pointers that meet the following criteria:

- Labeled with FDA CDRH certification stating "DANGER: Laser Radiation" for Class IIIa lasers or "CAUTION: Laser Radiation" for Class II pointers.
- Classified as Class II or IIIa according to the label. Do not use Class IIIb or IV products.
- Operates at a wavelength between 630 nm and 650 nm.
- Has a maximum output of less than 5mW.

Potential Hazards

The hazards of laser pointers are limited to the eye. Although with most visible lasers the largest concern is potential damage to the retina, most laser pointers are not likely to cause retinal damage. The possible exception might be the green light lasers. (You will use a red-laser light.)

The most likely effects from exposure to viewing the beam from a laser pointer are flashblindness, afterimage and glare. Flashblindness is temporary vision impairment after viewing a bright light. This is similar to looking directly at a flashbulb when having a picture taken. The impairment may last several minutes.

Afterimage is the perception of spots in the field of vision. This can be distracting and annoying, and may last several minutes, although there have been reports of afterimages lasting several days.

Glare is a reduction or complete loss of visibility in the central field of vision while being exposed to the direct or scattered beam. This is similar to viewing oncoming headlights on a dark night. Once the beam is out of the field of vision, the glare ceases. While this does not pose a hazard to the eye, it can cause serious distraction. Glare can be exacerbated when the beam is reflected from a mirrorlike surface.

Lens

The lens is used to expand the narrow laser beam enough to cover your hologram recording plate.

Requirements

A variety of lenses will work, though double-concave lenses work best. Double-concave lenses have two inward curved sides and negative focal length. (See figure 5.3.) Use a lens that, when placed at a lens-to-recording plate distance of 60.96 cm (24 inches), spreads a beam wide enough to completely cover the recording plate without overlapping it too much.

Recommendations and Suppliers

We recommend a lens available via mail order from Edmund Scientific, part number 32-988. It has a suggested retail price of $15.00. It can be ordered by contacting:

Edmund Scientific
101 East Gloucester Pike
Barrington, New Jersey 08007-1380
Phone: (856) 573-6250
Fax: (856) 573-6295
Web site: www.edmundscientific.com.

Other "negative" lenses may be used, providing that they have a -6 to -12 focal length.

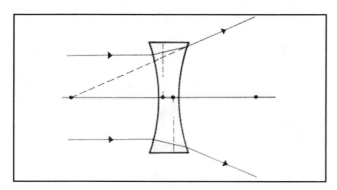

Fig. 5.3. A diagram of a double-concave "negative" lens.

Object

The object is the thing you will be making a hologram of. Choose an object carefully.

Requirements

The object must be small enough to fit on your vibration isolation table behind your recording plate holder. It should be small enough to be seen through the "window" of the recording plate (which measures 6.35 cm [2.5 inches] square).

The object must be completely stable. Avoid using flimsy objects or objects with moving parts. Items such as feathers, flowers, fabric, etc., will not record well because they are not stable. Avoid using round objects that could roll or objects that could fall over.

The object should reflect red light. A white object works very well. Avoid dark-colored objects, especially those colored blue or green.

Recommendations

Highly detailed "dimensional" objects with textured surfaces or many facets are interesting to look at.

Items that work well include:

- ocean coral
- seashells
- porcelain figurines
- ceramic figurines
- pewter figurines
- metal car models
- painted blocks

An old favorite of holographers is a white chess piece. It is small, detailed and reflective.

Hologram Recording Materials

Requirements

Recording media for holography are expensive since they are not mass market items and take specialized knowledge and equipment to manufacture. This experiment is based around glass plates measuring 6.35 cm (2 ½ inches) x 6.35 cm (2 ½ inches) that have been coated with a red-sensitive, silver halide emulsion.

Recommendations and Suppliers

This book recommends using the BB-640 plates from a German manufacturer called Holographic Recording Technologies (HRT). The plates have a sensitivity of 580 nm–650 nm and are especially sensitive to 633 nm and 647 nm. (See figure 5.4.)

Fig. 5.4. A graph showing the sensitivity to various wavelengths of HRT BB-640 hologram recording plates.

At this time, you can only order boxes containing 20 small plates, though we encourage you to ask your distributor if other quantities have become available. A box of 20 plates has a suggested retail price of $70. Listed below are German and American addresses for HRT plates. A complete worldwide list of HRT suppliers is provided at the end of this chapter.

HRT GmbH
Am Steinaubach 19
36396 Steinau
Germany
Phone: 49-6663-7668
Fax 49-6663-7463
Web site: www.holographic–materials.de.

One USA distributor for HRT plates is:
VinTeq, Ltd.
611 November Lane / Autum Woods
Willow Springs, NC 27592
Phone:l (919)639-9424
Fax (919)639-7523.
Web site: www.vinteq.com.

Other Suitable Silver halide Recording Materials

There are several other sources for silver halide glass plates that can record reflection display holograms. Most notable is Slavich, a Russian manufacturer. Its plates have slightly different characteristics than the HRT materials and require slightly different developing and processing techniques. One product, the PFG-01 plates, can be exposed sufficiently with the laser light emitted from a diode laser. Exposure time may vary from that suggested for this experiment.

Slavich holography materials can be ordered from distributors around the world. A listing of them can be found on its Web site: www.slavich.com.

It is possible to record holograms on a flexible film, rather than on glass plate. Red-sensitive silver halide emulsions suitable for holography have been available on film substrates in the past. However, working with flexible film requires making a mount that will hold the film motionless for the length of the exposure. Rigid glass plates are easier and more practical for beginners to work with.

Note: If you find silver halide hologram recording materials from manufacturers other than those mentioned (such as Agfa, Kodak, Red Star), it may be possible to employ them if you have pertinent information regarding sensitivity and photochemistry. This information is available in many books (*Holography MarketPlace*, *Holography Handbook*, etc.) and on the Internet at holography related web sites. You will probably have to adjust exposure times and developing procedures.

Recording Material Developing and Processing Kit

Many chemical supply houses stock the photo-chemicals needed to develop and process the hologram recording materials you will use in this experiment. It is possible to order these chemicals individually and in bulk. However, for convenience sake, you may wish to purchase them in a prepackaged kit containing pre-measured amounts suitable for a few hologram experiments.

The manufacturer of the recording plates you will use in this experiment provides several combinations of processing solutions that will work with their product. This book recommends a safe, affordable and proven combination. If you are interested in obtaining and trying other developing and processing formulations, please check with the manufacturer or a distributor. It is emphasized that nearly any kind of conventional hologram processing works with the bb-640 plates, manufactured by Holographic Recording Technologies (HRT).

Requirements

For this experiment you need to use developing and processing chemistry appropriate for making reflection display holograms on red-sensitive silver halide coated glass plates.

Recommendations and Suppliers

The experiment in this book is based around the JD-2 kit, which makes enough solutions to developing and process 20 HRT plates.

The kit contains all the chemicals needed to mix a two-part developer. Mixing the two solutions together just before the experiment helps insure the developer is "fresh" and "reactive". The kit contains:

Catechol	20 g
Ascorbic Acid	10 g
Sodium Sulfite	10 g
Urea	75 g
Sodium Carbonate, Anhydrous	60 g

The kit also contains all the chemicals needed to make a bleach solution:

Potassium Dichromate	5 g
Sodium Bisulfate	80 g

The JD-2 kit has a suggested retail price of $14.95. It is available from Photographers Formulary. The address is:

Photographers Formulary.
HC 31 Box 89 / P.O. Box 950
Condon, MT USA 59826.
Phone: (800) 922-5255.
Web site: www.photoformulary.com.

Note: The developing instructions that come with the JD-2 kit were designed for a different recording material than the one used in this experiment. Hence, the kit suggests a developing time of two minutes. The HRT plates require *7.5 minutes* of developing based on the recording procedures outlined in this book.

See Appendix A for an alternate developer, bleach and processing procedure.

Some Recommended References

Here are some additional sources of information regarding developer and bleach formulations that have been recommended by HRT. The HRT Internet web site (www.holographic–materials.de.) also has related information.

H.I. Bjelkhagen, *Silver Halide Recording Materials for Holography and Their Processing*. Springer, 1988.

A. Rhody, F. Ross, *Holography MarketPlace, 7th Edition*. Ross Books 1998.

A. Rhody, F. Ross, *Holography MarketPlace, 8th Edition*. Ross Books, 1999.

Graham Saxby, *Practical Holography*, Prentice Hall, 1988;

Graham Saxby's *Manual of Practical Holography*. Focal Press, 1991.

Vibration Dampers

There are many devices sold to dampen vibration, but among the simplest and least expensive is a small hemisphere of foam-like substance called sorbothane. A description in Edmund Scientific's product catalog says, "Patented Sorbothane polymer combines the dimensional stability of a solid with the physical properties of a liquid. Absorbs (60% absorption efficiency) and dissipates energy (75% specific damping), and reduces vibration to other components by isolating the vibrations within the material while dealing with multi-directional forces. Can keep equipment weighing under 60 pounds (132 kg)stable." Sorbothane was first used in holography by Thomas Altman in the 1980s. It is available from science supply outlets.

A similar-acting material is found in "Lazy Balls": beanbaglike cushions used to isolate optical equipment from vibrations in the environment.

Recommendations and Suppliers

Edmund Scientific sells a set of four vibration isolators for $15.25: #H35264. To order, contact:

Edmund Scientific
101 East Gloucester Pike
Barrington, New Jersey 08007-1380
Phone: (856) 573-6250
Fax: (856) 573-6295
Web site: www.edmundscientific.com.

Damping vibration is not just a problem for holographers. Many audio enthusiasts need to isolate their stereo components from unwanted motion. You can often find vibration-isolation "feet" at stereo stores for approximately $10.00.

Green Filtered Safelight

A safelight is a light that can be used to illuminate a holographer's work area without danger of exposing the recording material.

Requirements

Photographers typically work under a red filtered light but you, like all holographers working with red-sensitive recording materials, *must* use a green filtered light. This is because the HRT bb-640 recording plates are much less sensitive to green light than they are to the red laser light that is used to expose them. Therefore, it is possible for you to safely work under a dim green light when the room lights are turned off (i.e., when loading your recording plate in the holder and when you are developing and processing the plate in the darkroom).

Recommendations and Suppliers

Home & garden centers (such as Home Depot) sell a green phosphorescent night light, called the LimeLight, for $3.99. It plugs into a wall outlet (or extension cord) and works well as a safelight. Similar green phosphorescent lights also will work.

Stephen Michael recommends this approach: "I have successfully fashioned a safelight using a small flashlight (2 AA batteries) and a Tricolor Green filter (available from Edmund Scientific # J53-701 for $19.95). To make one, first unscrew the lamp housing. Second, cut out three circles from the filter (the same size as the plastic flat lens in the flashlight). Then, stack them together with another small circle cut from standard white "copy" paper (it acts as a diffuser). Place all four filters in the lamp using the plastic flat lens to hold the filters against the screw-on housing. During the experiment, I kept the flashlight a meter or so (a yard) from the plates."

Many photography supply stores sell a variety of safelights and filters. You may be able to purchase a used safelight (hobbyists frequently sell their equipment) and modify it with a green filter. Use Kodak's #3 dark green filter.

Distributors for HRT BB-640 Hologram Recording Plates Worldwide

Australia
Coherent Scientific PTY., Ltd.
116 Burbridge Road
Hilton, S.A. 5033
Phone: 08-8352-1111
Fax: 08-8352-2020

Chile/South America
Tecnologia Omega Ltda.
Padre Luis de Valdivia 346, Of. 304
Santiago
Phone: +56-2-6397806
Fax: +56-2-6325738

China
Hua Tong Holdings Corporation
Unit No. 2609-2611, Zhongshen Building, Caitian
South Road
Shenzen, Guangdong, 518026
Phone: +86-755-3822984 or +86-755-3822565;
Mobile: 13602674325
Fax: +86-755-3822984

France
ABSYS S.A.
7 rue Soddy — Creteil Parc
94044 Creteil
Phone: 01-49-569100
Fax: 01-49-569162

India
System Tech Enterprises
#58, 1st Floor 'Seetha Nivas'
D.N. Ramiah Layout, R.M. Guttahalli
Bangalore — 560 020
Phone: 91-80-3310540, 3363381, 3444714,
3444716
Fax: 91-80-3342962

Italy
DIMART s.r.l.
Via A. Einstein, 13
20018 Sedriano
Phone: 02-90310207
Fax: 02-90310208

Japan
Central Trading Co., Ltd.
Oikawa Bldg., 2F, 1-5, Kanda Awaji-cho
Chiyoda-ku, Tokyo 101-0063
Phone: 3-3257-1966
Fax: 3-3257-1963

Netherlands
Dutch Holographic Laboratories BV
Kanaaldijk Noord 61
5642 JA Eindhoven
Phone: 040-2817250
Fax: 040-2814865

Spain
Lasing S.A.
Marques Pico Velasco, 64
28027 Madrid
Phone: 341-377-5006
Fax: 341-407-3624

Taiwan
Onset Electrooptics Co. Ltd.
7F-5, No. 151, Sec. 4, Hsing Lung Rd.
Taipei
Phone: 886-2-29385595
Fax: 886-2-29384556

United Kingdom
Holographic Materials Distributors
38, Arlington Road
Southgate, London, N14 5AS
Phone: 0181-368 6425
Fax: 0181-361 8761

Spectrolab Analytical Ltd.
12 Langley Court
Beedon, Newbury, RG20 8RY
Phone: 01635-248080
Fax: 01635-248745

USA
VinTeq, Ltd.
611 November Lane
Willow Springs, NC 27592-7738
Phone: (919) 639-9424
Fax: (919) 639-7523

The Experiment

Module 1

Preparing the Laser

This module explains how to prepare your laser pointer or your pre-wired diode laser for making holograms.

Module 1 Goal

Your goal is to ensure that there is a reliable and constant source of power to your laser.

Introduction

The experiment described in this book can be performed using either an ordinary laser pointer or a pre-wired diode laser. (See figure M1.1.)

If you are using a *laser pointer*, there are two ways to provide an adequate amount of power to it. Both methods are described in detail below. Method 1 is the simplest. It involves getting a second set of laser pointer batteries. Method 2 takes a small amount of electrical wiring ability. It involves connecting the laser pointer to an external power supply. Review both methods and choose the one that works best for you. Method 2 is recommended if you feel confident enough.

Fig. M1.1. *An ordinary laser pointer (on a keychain) next to a pre-wired diode laser.*

If you are using a *pre-wired diode laser*, proceed directly to Method 3. Since the pre-wired laser diode does not come with a power supply, you will have to connect it to a pair of batteries.

Note to Instructors

The activities described in Methods 2 and 3 are especially appropriate for any student who has an interest in basic electronics. Related study topics include electronics, circuitry and batteries.

Method 1 (for Laser Pointers): Using Two Sets of Laser Pointer Batteries

Equipment needed:

 1 laser pointer (See Chapter 5 for recommended specifications.)

 6 laser pointer batteries (You already have 3 that came with your laser pointer.)

 Optional: 1 cotton swab with a small piece of double-sided tape attached to one end

 Optional: 1 photometer

Using Two Sets of Batteries

The laser inside your laser pointer is powered by batteries. The easiest thing to do in order to insure your laser has a reliable and constant source of power is to buy a set of spare batteries for your laser pointer.

The batteries used in laser pointers look like small metal disks. These batteries store and supply the *potential energy* that the diode laser inside your laser pointer converts into other types of energy—a lot of visible light and a tiny amount of heat. (The light is useful to holographers; the heat is an unwanted by-product.)

One side of each battery has a slightly raised terminal labeled negative or "-". The other side is flat and labeled positive or "+". The energy stored in the battery is released when a *conductive path* is placed between these two terminals. In general, the conductive path (called a *circuit*) used in a laser pointer is: battery terminal positive > screw cap > metal case > on/off button > laser diode circuitry > laser diode > metal spring > battery terminal negative. Since the metal case itself is conductive, it is used as part of the circuit.

Step 1: Remove the internal batteries.

a. Unscrew the cap of the laser pointer case to reveal the battery compartment. Before you take the original set of batteries out, notice which side of the top battery (positive or negative) faces towards the open end of the case and which side faces into the laser casing.

b. Dump the batteries out slowly. There are three batteries in a set. (See figure M1.2.) Notice how they are stacked. You should see that the raised negative terminal faces the front of the laser and the flat positive surface faces the screw-on cap. Write this information down (or draw and label a diagram) so you can reinstall the batteries correctly.

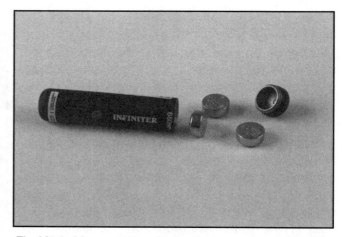

Fig. M1.2. A laser pointer with the the cap unscrewed and the three internal batteries removed.

Note: If you are using the Infiniter 200 laser pointer that is recommended in this book, the positive sides of the original batteries will be facing up (towards the screw cap) and the negative sides will be facing down (towards the spring).

Step 2: Get more batteries.

Locate a supply of three replacement batteries. Many stores sell these batteries, as similar ones are used in cameras and other small electrical devices. Be sure to buy the proper kind for your laser pointer. Take a sample battery to the store with you so you can find a correct match.

If you can't find identical replacements, check a manufacturer's catalog to find batteries with a matching size and voltage.

Note: The batteries that come with the Infiniter 200 laser pointer recommended for this experiment (LR44 watch batteries) are 1.5 volts each.

Step 3: Prepare two sets of batteries.

Divide your batteries into two sets – a practice set and an exposure set.

Use the practice set while adjusting and testing your optical system. Since you may have the laser pointer turned on for several minutes (or more) during the alignment process, this "practice" set of batteries can wear down relatively quickly. Low batteries will cause the beam to weaken even though the red spot of laser light may still appear very bright to your eyes. A fading beam can result in an underexposed hologram (not enough laser light reaches the recording material), which can result in a dim or nonexistent image.

Use the other set of batteries only during final alignment and exposures. Exposures are very short and the batteries should remain useful for many shots. Always using the freshest batteries available for exposures insures that you are getting the maximum output from the laser pointer when you need it most.

A useful tip: At some point in the laser beam alignment or hologram exposure process, you may need to switch from one set of batteries to another. If the laser pointer is already mounted and aimed, and you don't want to disturb the beam alignment, it is useful to make a simple tool to help you remove and reinsert the batteries. Put a small piece of double-sided tape on the tip of a cotton swab and use the sticky tape to pull the batteries out of the pointer while holding the laser still. Use the other end of the swab (without the tape) to push in another set of batteries.

Step 4: Reinstall one set of batteries.

Put the practice set of batteries back in the laser pointer. Always put the batteries back in the same way that they came out. Screw the cap on firmly.

Step 5 *(optional)*: Use a photometer.

It is possible to monitor the output of your laser pointer (or any laser) by using a tool called a photometer (pronounced fo-tom-e-ter). A photometer measures the amount of light reaching a sensor attached to the device and displays the measurement on a calibrated scale. If you do have access to a photometer, try using it.

a. Calibrate the meter's scale so it measures milliwatts.

b. Turn on the laser pointer and hold the sensor in the beam close to the laser. It should read in the range of 3 to 5 mW. When you hold the sensor in the beam far from the laser, the reading should be lower.

Whenever using your laser, you may want to periodically measure its output at a predetermined distance to check that the beam is not getting weaker. A weak beam (less than 2.5 mW exiting the pointer) usually indicates that your batteries are losing power and need to be replaced.

Method 2 (for Laser Pointers): Attaching Your Laser Pointer to Longer-lasting Batteries

Equipment needed:

1 - laser pointer (see Chapter 5 for recommended specifications)

2 - "D" cell batteries

1 - "D" cell battery holder (that holds 2 batteries)

2 - insulated alligator clips or similar clips. (Make sure to get the insulated ones covered with a plastic sleeve.)

A few pieces of electrical tape (approximately 2.54 cm [1 inch] long)

Optional: 2 pieces of thin, flexible, insulated 22 gauge copper wire or 2 lengths of wire that have pre-attached insulated alligator or insulated clips (each approximately 30 cm [12 inches] long)

Optional: 1 piece of paper-thin rubber hose or thin plastic tubing (3.81 cm [1 ½ inches] in length and 0.95 cm [3/8 inch] in diameter)

Using "D" Cell Batteries for Power

The batteries used in laser pointers look like small metal disks and are a bit smaller and thicker than a dime. These batteries store and supply the *potential energy* that the diode laser inside your laser pointer converts into other types of energy—a lot of visible light and a tiny amount of heat.

One side of each pointer battery has a slightly raised terminal labeled negative or "-". The other side is flat and labeled positive or "+". The energy stored in the battery is released when a *conductive path* is placed between these terminals. Since electricity travels well through metal (especially copper wire), it is used to connect components in the conductive path. In general, the conductive path (called a *circuit*) used in a laser pointer is: positive battery terminal > screw cap > metal case > on/off button > laser diode circuitry > laser diode > metal spring > negative battery terminal.

The batteries provided with your laser pointer will work OK; however, they do have a tendency to wear down rather quickly if the laser stays on for extended periods. And they are relatively expensive to replace.

For the experiments described in this book, you want to ensure that the laser always has enough power. Weak batteries will cause the laser beam to fade even though it may still appear bright. Method 2 describes a way for you to easily attach two ordinary "D" cell (flashlight) batteries to your laser in place of the batteries that came with your laser pointer. These batteries will provide a more reliable and longer-lasting amount of power. They are cheap and readily available.

If you have the most basic wiring skills, we recommend that you attempt the following procedure. In brief, you will substitute the "D" cell batteries for the original ones and attach them to the laser pointer with a short length of wire. The new conductive path will be: positive battery terminal > extension wire > metal case > on/off button > laser diode circuitry > laser diode > metal spring > extension wire > negative battery terminal.

Note: You may wonder why we are replacing *three* 1.5 volt laser pointer batteries with only *two* 1.5 volt "D" cell batteries. The answer is that it works well and protects the laser. Too much input power can burn up the laser. Using a little less power is a safeguard that still produces adequate light.

Step 1: Remove the internal batteries.

a. Unscrew the laser pointer case to reveal the battery compartment. Before you take the original set of batteries out, notice which side (positive or negative) of the top battery faces towards the open end and which side faces the front of the laser.

b. Dump the batteries out slowly. There are three batteries in a set. Notice how they are stacked. Write this information down (or draw and label a diagram). You will need to know it for the next step and if you ever reinstall these original batteries. Save these batteries for regular pointer use at a later time.

 Note: If you are using the Infiniter 200 laser pointer recommended in this book, the positive sides of the original batteries will be facing up (towards the screw cap) and the negative sides will be facing down (towards the spring).

c. Examine the inside of the battery compartment. Notice the metal spring. It is part of the electrical circuit.

Step 2: Make a new external power supply.

a. Place the 2 "D" cell batteries inside the "D" cell battery holder as indicated on the holder. The holder should come pre-wired so the negative end of one battery connects to a positive end of the other battery. This is called wiring the batteries in *series*.

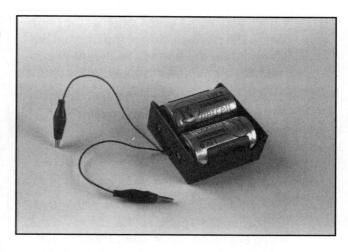

Fig. M1.3. Batteries installed in the external holder and alligator clips attached to the black and red wires.

b. The black wire coming from the "D" cell battery holder is negative. Connect it to the tail end (not the side that opens) of an insulated alligator clip or insulated spring clip. (Stick the wire in the small opening in the neck of the clip and wrap the bare wire around the clip. Crimp the clip and cover the connection with electrical tape.)

Optional: The black wire coming from the pre-wired battery holder is not very long — just a few inches. For convenience sake you may want to add an extension wire between it and the alligator clip. You can use a pre-made extension wire with clips on both ends (available at electronics stores) or make one yourself. To make one yourself, first remove a small amount of insulation on each end of the copper extension wire. You can easily twist one exposed end of the extension wire together with the exposed end of the black wire from the battery holder. Always wrap your connections with a piece of electrical tape. Attach the other end of the extension wire to the tail end of the alligator clip. Mark this extension wire as negative.

c. The red wire coming from the battery holder is positive. Connect it to the tail end (not the side that opens) of an insulated alligator clip or insulated spring clip.(Stick the wire in the small opening in the neck of the clip and wrap the bare wire around the clip. Crimp the clip and cover the connection with electrical tape.)

Optional: The red wire coming from the battery holder is not very long—just a few inches. For convenience sake you may want to lengthen it by adding an extension wire between it and the alligator clip. You can use a pre-made extension wire with clips on both ends (available at electronics stores) or make one yourself. To make one yourself, first remove a small amount of insulation from each end of the copper extension wire. You can easily twist one exposed end of the extension wire together with the exposed end of the red wire from the battery holder. Always wrap your connections with a piece of electrical tape. Attach the other end of the extension wire to the tail end of the alligator clip. Mark this extension wire as positive.

You now have a new power supply for your laser — two "D" cell batteries in an external holder with one positive and one negative wire coming off it. Each wire has an alligator clip attached to the loose end. (See figure M1.3.)

Step 3: Attach the new power supply.

a. Look down into the battery compartment of the laser pointer. You should see a metal spring. The goal is to attach the proper alligator clip to this connection *without the clip touching the sides of the battery compartment.* This is imperative, as the proper electrical circuit will be *shorted out* if the metal spring and the metal case are accidentally wired together. A short circuit (one that doesn't follow the desired conductive path) can harm your laser.

b. Check your notes to see whether the negative or the positive side of the original batteries faced the spring. You want to connect the new power supply in the same way.

Note: If you are using the Infiniter 200 laser pointer, you will connect the *negative* lead from your battery holder to the spring (you can say that the spring is negative).

c. Open the jaws of the negative alligator clip and grasp the spring so the clip stays put. If you are using conventional "toothed jaw" alligator clips or a spring clip, make sure the insulation sleeve is pulled over the

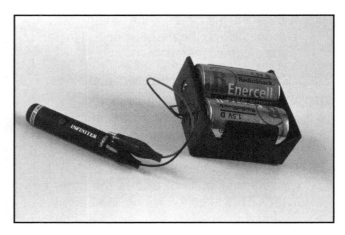

Fig. M1.4. External battery holder wired to the laser pointer.

metal surfaces of the clip. It is important to have a secure connection. If the insulated clip is too big to fit into the casing, get a narrower clip at an electrical supply store or, as a last resort, use a non-insulated clip along with an insulating sleeve (described below).

Optional: To best prevent an accidental short circuit from occurring, you can make an insulating sleeve for the inside of the battery case. Cut a short length of thin rubber hose or of very thin-walled plastic tubing (3.81cm [1 ½ inches] in length and 0.95 cm [3/8 inch] in diameter) and slide it into the battery case over the spring. A small piece of rolled-up cardboard will work as well. This insulating sleeve will prevent the negative clip and the negative spring from ever touching the positive metal casing.

d. Clamp the other, positive alligator clip or spring clip over the edge of the battery compartment casing. The electricity needs to flow through the metal case, so be sure to have a secure connection. Other metal surfaces on the pointer will also work as a contact point, but the edge of the battery compartment is the securest location. Make sure this metal clip does not touch the other metal clip. (See figure M1.4.)

Step 4: Test the new power supply.

Aim the laser towards a wall, away from any person. Press the "on" button. You should see a red spot of light on the wall. This indicates you have hooked up your power supply correctly.

Possible Problems and Solutions

If you do not see laser light output, it probably means that you have:

• a loose connection. Reposition each alligator clip to make sure it is making good contact with the proper point on the laser pointer. If you added a length of extension wire, recheck your connections to make sure they are good and secure.

• an electrical short. Make sure that negative circuit components are not touching positive ones (for instance, that the metal spring has not bent and come in contact with the inside wall of the pointer).

• batteries in the holder wrong. Make sure batteries are installed in the holder correctly.

• bad batteries. It's unlikely if new, but the "D" cell batteries you are using could be depleted. Try using a new pair of "D" cell batteries. Test the laser pointer with your new power supply.

As a last resort, reinstall the batteries that came with your pointer, screw the case shut and press the "on" button. If your laser works now, you know that the laser pointer itself works fine and something in your external power supply is faulty. You can try to fix the problem by trying Method 2 again, or you can use Method 1.

Method 3 (for Pre-wired Diode Lasers): Attaching Your Pre-wired Diode Laser to a Power Supply

Equipment needed:

> 1 - pre-wired diode laser (See Chapter 5 for recommended specifications.)
>
> 2 - "D" cell batteries
>
> 1 - "D" cell battery holder
>
> 2 - pieces of electrical tape (approximately 2.54 cm [1 inch] long)
>
> *Optional*: 2 pieces of thin flexible insulated copper wire (each approximately 30 cm [12 inches] long), and 1 alligator clip. Or 2 lengths of wire that have pre-attached insulated alligator clips (or insulated spring clips)
>
> *Optional*: 2 additional pieces of electrical tape (approximately 2.54 cm [1 inch] long)

Using "D" Cell Batteries for Power

If you are using a pre-wired diode laser for this experiment (rather than a laser pointer) you will have to attach a power supply to it. Method 3 describes a way for you to easily attach two ordinary "D" cell (flashlight) batteries to your diode laser. These batteries will provide a reliable and long-lasting amount of power. They are cheap and readily available.

As you've probably noticed in the past, one side of each battery has a slightly raised terminal labeled *positive* or "+". The other side is flat and labeled *negative* or "-". The energy stored in the battery is released when a *conductive path* is placed between these terminals.

Fig. M1.5. External battery holder wired to the pre-wired diode laser.

If you have the most basic wiring skills, we recommend that you attempt the following procedure. In brief, you will attach the "D" cell batteries to your diode laser with a short length of wire. The conductive path (called a *circuit*) will be: positive battery terminal > extension wire > laser diode circuitry > laser diode > extension wire > negative battery terminal. (See figure M1.5.)

Notice that there is no on/off button in the circuit. Removing one battery will break the circuit and turn the laser off. Or, it may be easier for you to switch the laser on and off by connecting and disconnecting one of the wires. See below for more details.

Step 1: Make a power supply.

a. Place the 2 "D" cell batteries inside the "D" cell battery holder as indicated on the holder. The holder should come pre-wired so the negative end of one battery connects to the positive end of the other battery. This is called wiring the batteries in *series*.

b. Remove one battery from the holder while performing Step 2.

Step 2: Attach the power supply.

a. The black wire coming from the "D" cell pre-wired battery holder is negative. Connect it to the black (negative) wire coming from the diode laser. Wrap the connection with tape.

 Optional: The black wire coming from the pre-wired battery holder is not very long — just a few inches. For convenience sake you may want to add an extension wire between it and the

diode laser. You can use a pre-made extension wire with clips on both ends or make one yourself. To make one yourself, first remove a small amount of insulation from each end of the copper extension wire. You can easily twist one exposed end of the extension wire together with the exposed end of the black wire coming from the battery holder. Twist the other end together with the exposed end of the black wire coming from the diode laser. Always wrap your connections with a piece of electrical tape. Mark this extension wire as negative.

b. The red wire coming from the battery holder is positive. Connect it to the red (positive) wire coming from the diode laser. Wrap the connection with electrical tape or, if you want to make an on/off switch, read the following instructions.

Making an On/Off Switch

a. Insert the red (positive) wire coming from the battery holder into the slotted end of the alligator clip. Crimp and tape the connection in place.

b. Clamp the alligator clip to the positive wire coming from the diode laser, instead of wrapping and taping the two ends together. Disconnecting the wires provides an easy way to break the circuit when you want to turn the laser off. In essence, the alligator clip is your on/off switch.

Optional: The red wire coming from the battery holder is not very long — just a few inches. For convenience sake you may want to lengthen it by adding an extension wire between it and the diode laser. You can use a pre-made extension wire with clips on both ends or make one yourself. To make one yourself, first remove a small amount of insulation from each end of the copper extension wire. You can easily twist one exposed end of the extension wire together with the exposed end of the red wire coming from the battery holder. Twist the other end together with the exposed end of the red wire coming from diode laser. Always wrap your connections with a piece of electrical tape. Mark this extension wire as positive.

You now have a new power supply for your laser diode — two "D" cell batteries in an external holder with extension wires running to the diode laser.

Step 3: Test the new power supply.

a. Aim the diode laser toward a wall, away from any person.

b. Place the battery you had previously removed from the holder back in the holder in the correct position. You should see a red spot of light on the wall. This indicates you have hooked up your power supply correctly.

Possible Problems and Solutions

If you do not see laser light output, it probably means that you have:

• a loose connection. Reposition each alligator clip to make sure it is making good contact with the proper point on the laser pointer. If you added a length of extension wire, recheck your connections to make sure they are good and secure.

• an electrical short. Make sure that negative circuit components are not touching positive ones.

• batteries in the holder wrong. Make sure batteries are installed in the holder correctly.

• bad batteries. It's unlikely, but the "D" cell batteries you are using could be bad. Try using a new pair of "D" cell batteries. Test the diode laser with the new power supply.

If the laser diode still doesn't work, you may have a bad diode laser. You may need to try a new one. Before replacing it, repeat all the steps in Method 3 to make sure you didn't overlook something that would cause your diode laser not to work.

Module 2

Component Assembly

This module explains how to assemble the basic components needed to make a hologram recording setup.

Module 2 Goal

Your goal is to assemble three component holders, build a vibration isolation table and construct a shutter using readily obtainable and inexpensive materials.

Introduction

It is not possible to hold the laser, the lens, the recording plate or the object by hand during the hologram exposure period. You need to build stable holders for all of the components. It helps to build vertically adjustable holders for the laser and the lens. It is necessary to build a flat, vibration isolation table for the recording plate and the object. In addition, you will need to fashion a simple device to hold the recording plate stationary during the exposure and a shutter to control the exposure length.

Note to Instructors

The activities described in this section are especially appropriate for any student interested in basic building and assembly procedures. Related study topics include structural engineering, vibration isolation and magnetism.

Step 1: Make a laser holder.

Equipment Needed:

 1 - length of metal pipe (1.3 cm [1/2 inch] diameter, 20.32 cm [8 inches] long) threaded on at least one end

 1 - round metal flange with flat base (7.62 cm [3 inch] diameter) that the pipe can screw in to

 1 - spring clip that opens wide enough to clamp on the pipe (5.08 cm [2 inches] wide)

 1 - spring clip that opens wide enough to clamp on the laser (2.54 cm [1 inch] wide)

 1 - operating laser pointer or pre-wired diode laser

 1 - clothespin (that can clamp around the laser pointer)

The Laser Holder

In this step we will build a laser holder using readily obtainable supplies. We need to build a holder that is rigid and sturdy so the laser does not move while we are exposing the hologram recording plate. It is helpful to make a holder that lets you adjust the height of the laser, too.

Step 1.1: Connect the pole and base.

The holder consists of a pole supported by a flat base. We will use a length of metal pipe as the upright and a metal flange as a base. Most hardware stores will stock these items.

a. Get a short length of metal pipe with at least one threaded end. A galvanized steel plumbing pipe works well. Get a round flange with a threaded hole that the pipe can screw into. Try this combination in the store before you buy it. Find ones that fit together well.

b. Use the flange as the base and stand the pole upright. Make sure the flange has a very flat bottom so the pole does not wobble. (Since these flanges are meant to be screwed into a wall and not to be used as a base support, the bottom of the flange may not be completely flat. Choose the one that is the most stable.)

A useful tip: If the pole does wobble, you must create a stable base. A simple solution is to place three coins underneath the flange. These "feet", arranged as a tripod, will keep the base stable. Or, many hardware stores sell hard plastic feet that can be stuck on the bottom of the flange. (Avoid using paper wedges; you don't want the base support to be at all springy.)

Step 1.2: Make the laser/clip assembly.

a. Clamp the laser pointer or laser diode lengthwise with the 2.54 cm [1 inch] spring clip so that the end where the beam comes out of protrudes a bit. (See figure M2.1.)

b. Place the laser/clip assembly against the upright pole so that the handles of the spring clip face the pole and the laser is pointing horizontal (sideways).

c. Clamp the larger, 5.08 cm [2 inch] spring clip around the pole and the handles of the smaller clip.. The larger clip is now pinching the smaller clip (with the laser) securely against the pole. (See figure M2.2.)

You now have a laser holder that you can easily adjust. Squeezing the handles of the smaller clip will let you adjust the laser. Squeezing the handles of the larger clip will let you slide the laser/clip assembly up and down the pole in order to adjust the height of the laser beam. (You may find other ways to securely attach the laser to the pole. Make sure the laser is horizontal and its height can be adjusted.)

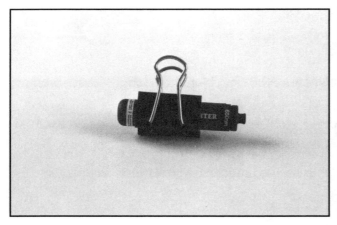

Fig. M2.1. The smaller spring clip clamped around the laser pointer.

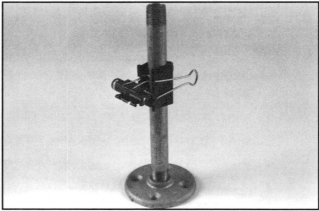

Fig. M2.2. The larger spring clip clamped around the pole and the handles of the smaller clip.

If you are using a laser pointer you will need access to the on/off button.

a. Clamp the pointer in the small clip so the on/off button is exposed. Rotate the pointer in the small clip so the button faces up (towards the ceiling).

b. Clamp a clothespin on to the laser pointer next to the button.

When you want the laser on, carefully slide the clothespin over the button, so that the button is depressed. When you want the laser off, slide the clothespin off of the button.

A useful tip: If you are using a laser pointer with an external power supply, the best way to avoid accidentally knocking the laser beam out of alignment when turning the laser on and off is to always keep the clothespin clamped over the button. Turn the laser on and off by carefully disconnecting an electrical connection (i.e., unclamp an alligator clip).

Step 2: Make a lens holder.

Equipment needed:

1 - length of metal pipe (1.3 cm [1/2 inch] diameter, 20.32 cm [8 inches] long) threaded on at least one end

1 - round metal flange with flat base (7.62 cm [3 inch] diameter) that the pipe can screw in to

1 - spring clip that opens wide enough to clamp on the pipe (5.08 cm [2 inches] wide)

1 - spring clip that opens wide enough to clamp on the lens (2.54 cm [1 inch] wide)

1 - lens

1 - soft, lint-free cloth

• - a few pieces of double-sided tape

The Lens Holder

In this step we will build a lens holder using readily obtainable supplies. We need to build a holder that is rigid and sturdy so the lens does not move while we are exposing the hologram recording plate. It is helpful to make a holder that lets you adjust the height of the lens, too.

Step 2.1: Connect the pole and base.

The holder consists of a pole supported by a flat base. We will use a length of metal pipe as the upright and a metal flange as a base. Most hardware stores will stock these items.

a. Get a short length of metal pipe with at least one threaded end. A galvanized steel plumbing pipe works well. Get a round flange with a threaded hole that the pipe can screw into. Try this combination in the store before you buy it. Find ones that fit together well.

b. Use the flange as the base and stand the pole upright. Make sure the flange has a very flat bottom so the pole does not wobble. (Since these flanges are meant to be screwed in to a wall and not used as a base support, the bottom of the flange may not be completely flat. Choose the one that is the most stable.)

A useful tip: If the pole does wobble, you must create a stable base. A simple solution is to place three coins underneath the flange. These "feet", arranged as a tripod, will keep the base stable. Also, many hardware stores sell hard plastic feet that can be stuck on the bottom of the flange. (Avoid using paper wedges; you don't want the base support to be at all springy.)

Step 2.2: Make the lens/clip assembly.

Handle the lens with a cloth whenever possible and by the edge only. Scratches, fingerprints and particles of dirt on the front or back surface of the lens could ruin your hologram.

Fig. M2.3. The smaller spring clip clamped around the lens.

Fig. M2.4. The larger clip clamped around the pole and one handle of the smaller spring clip.

a. Clamp the very edge of the lens with the 2.54 cm [1 inch] spring clip so that the lens is firmly clamped. Make sure that the center portion of the lens is totally unobstructed. Be very gentle—the glass lens is very delicate. Avoid cracking or chipping the glass. A small piece of double-sided tape placed on each lip of the clip will help cushion the glass lens and prevent the glass from chipping. There is no need to move the lens once it is clamped in place. (See figure M2.3.)

b. Place the lens/clip assembly against the upright pole so that the handles of the spring clip are sideways. One handle of the spring clip should be flush against the pole.

c. Clamp the 5.08 cm [2 inch] clip around the pole and this handle. (See figure M2.4.)

You now have a lens holder that you can adjust easily. The lens/clip assembly should be protruding out from the pole so that a laser beam can be aimed right through the center of the lens. Squeezing the handles of the larger clip will let you slide the lens/clip assembly up and down the pole.

Step 3: Make a vibration isolation table.
Equipment needed:

> 2 - stone patio blocks or concrete slabs (at least 20.32 cm [8 inches] square)

> 4 - sorbothane vibration absorbers

> *Optional, but highly recommended*: 1 steel or iron plate (20.32 cm [8 inches] square) with smooth surfaces

Vibration Isolation

The object of this step is to create a small table that does not move the slightest bit. Movements too small for you to perceive can ruin your hologram, so even though this step looks easy, it is important that you build this vibration isolation table correctly.

We are trying to isolate the components on the holography table from vibrations in the same room (footsteps), in the same building (doors slamming, toilets flushing) and even the surrounding neighborhood (passing cars, trucks and trains). The rule of thumb is: if you can see it move, hear it, or feel it rumble; it's definitely trouble for your hologram!

To stop the surrounding environment from shaking the components you will place on your table, we must build a structure that does not transmit vibrations well and absorbs those vibrations that do occur. Holographers have found that if you place a very heavy, dense object on the proper type of cushion and stack that array on top of another very heavy, dense object, vibrations traveling through the ground can be drastically reduced.

This is due to the fact that objects with a lot of mass are difficult to move (vibration is movement) and cushions are not efficient energy transmitters — they absorb and dissipate energy. For instance, it is difficult to hear sounds through a foam pillow, since the material muffles, or absorbs, most sound waves.

Professional holographers often employ massive metal tabletops that actually float on a cushion of air. These vibration isolation tables can cost tens of thousands of dollars and weigh several tons. Hobbyists have built analogous structures using heavy sandboxes resting on partially inflated inner tubes. A sturdy box filled with sand is quite massive and the sand is easy to obtain and transport. See The *Holography Handbook – Making Holograms the Easy Way* (also from Ross Books) for instructions on constructing an inexpensive yet effective sandbox vibration isolation table.

Step 3.1: Build a vibration isolation table.

a. Place one patio block on the floor. Make sure the bottom surface is completely flat and the block does not rock back and forth.

b. Place a sorbathane vibration absorber on each corner of the top surface of the block. (See figure M2.5.)

c. Place the second patio block on top of the four sorbathane absorbers so it makes a sandwich: a block, four absorbers, a block. You should not be able to shake the blocks easily. If they do move, reposition the blocks and the absorbers until you find the most stable arrangement.

Fig. M2.5. Four sorbothane vibration absorbers on a concrete block. Place another block on top of these to make a stable table.

You now have a low table that you can use to put the recording plate holder and an object on. Be sure to check that the top surface is level. You do not want to put the hologram recording plate holder or the object on a bump. Turn the block over or reverse the blocks if needed.

Substituting Building Materials

It is possible to substitute other materials for those mentioned.

If you can not find patio blocks at a home and garden store, other commonly available building supplies can work. Just make sure they are equally as massive and they rest completely flat on the floor. You don't want the table you build to rock back and forth. Cinder blocks are bigger than patio blocks and usually not as dense, but they can work if you find blocks that are not too thick. (Two ordinary cinder blocks stacked together will be taller than the height of the poles holding the laser and the lens.) Heavy stone or metal slabs can be used as well. A sturdy wooden box filled with sand will work, too (*note* – sand can scratch lenses and glass plates, so the sandbox should have a lid). Make two sandboxes — one for the base of the table and another for the top. Use thick sheets of wood to make the boxes so they don't flex. Put a steel or iron plate on top of the upper box.

If you can not get sorbothane vibration absorbers you can substitute similar materials. Some laser and optics manufacturers sell vibration-absorbing Lazy Balls™ that feel like beanbags filled with special pellets. Many audio/video stores sell vibration isolation feet for CD players, turntables and stereo speakers that also work well. Some types of rubber will work if not too rigid or too bouncy.

A practical and cheap alternative to sorbothane vibration absorbers is a small inner tube from a wheelbarrow. These are available at many hardware stores or lawn and garden supply stores. Place the inner tube on the bottom block. Inflate the inner tube until it is firm to the touch but you can still press

your finger into it easily (about 2.5 cm [an inch]). Placing the top block on the inner tube should make the tube bulge out a bit. The idea is to have the air within the inner tube deaden any vibrations passing through the block below. (See The *Holography Handbook – Making Holograms the Easy Way* for detailed instructions about constructing inexpensive yet effective vibration isolation tables that are built using inner tubes.)

Step 4: Make the recording material holder.

Equipment needed:

> 1 - vibration isolation table, fully assembled
>
> 2 - strong, rectangular magnets (approximately 2.54 cm [1 inch] by 3.81 cm [1½ inch])
>
> 1 - white card (6.35 cm [2 ½ inches] by 6.35 cm [2 ½ inches])
>
> *Optional*: a few pieces of electrical tape

Another Stable Component Holder

Your table needs to hold a hologram recording material and the object that you are making a hologram of. The recording material you will be using is a piece of specially coated glass plate measuring 6.35 cm (2 ½ inches) square. The object you are making a hologram of will be approximately that size too. The glass plate will be positioned so that the laser beam strikes the glass plate at a 45 degree angle. The object will be positioned behind the glass plate. The hologram recording setup will be described in exact detail in a following module.

The main objective of this step is to make a device that will hold the glass plate completely immobile during the exposure. Since we will be loading our glass plate into the holder in the dark (so we don't expose it before we want to), the holder needs to be easy to open and close.

Note: For practical purposes, you will always substitute a white card for the recording plate until you are ready to make an exposure. It is much easier to position the laser beam using the white card since the red laser light shows up very well on it.

Step 4.1: Make a holder using a pair of magnets.

Magnetism is a natural force characterized by a bipolar field, i.e., a north and a south pole. Magnets are objects that are surrounded by a magnetic field. The magnetic field is invisible to the eye but its effects can be detected easily. Magnets can attract or repulse other magnets, depending on how each is aligned. They also attract iron and steel.

You will use a pair of magnets as supports and sandwich the card between them to hold it upright. The magnets should be strong enough to attract each other through a piece of thin glass (.15 cm [1/16 inch]). You can test the strength of the magnets using a paper card of equal thickness to such a glass plate.

a. Place two magnets flat-side down on the tabletop so that the long edges of the magnets stick together. (In one of the next modules, you will learn where to position the magnets on the table in preparation for an exposure.) (See figure M2.6.)

b. Stand the card upright between the long sides of the two magnets. The card should now be supported by the magnets, which are pulling towards each other through the card. Position the magnets in the middle of the card (since the card is 6.35 cm [2 ½ inches] long and the magnets are shorter, the edges of the card should protrude equally). (See figure M2.7.)

A useful tip: Some magnets are gritty or have uneven surfaces. It is imperative that the holder is completely stable. If grit gets between the magnet and the glass plate, it could allow the plate to jiggle enough to ruin your hologram. If grit or an uneven surface seems to be a problem, clean the magnets as best as possible and wrap a small piece of electrical tape around the magnet one or two times. This will create a thin padding. Test the holder again to make sure the magnets still attract and the card is held firmly in place.

Step 4.2 *(optional, but highly recommended)*: Make a magnetic tabletop.

If you place a steel or iron plate on top of the vibration isolation table, the magnets will stick better and the recording plate holder will be even more stable. The weight of the metal plate will add to the stability of the table, too. If a steel or iron plate is unobtainable, Stephen Micheal suggests using a small sheet of galvanized tin duct metal., available at many hardware stores. Since a sheet of this material is thin and somewhat flexible, you will have to epoxy it to the top surface of your stone block tabletop. Be sure and let the glue dry completely before use. Be sure to tape over any sharp edges.

Fig. M2.6. An object (a seashell) is positioned behind two magnets (the recording plate holder). In this setup a steel plate is used as a magnetic tabletop.

a. Remove the recording plate holder from the table and place a steel or iron slab on the tabletop. Be sure the bottom surface of the metal plate is completely flat and does not rock back and forth at all. Be sure the top surface is completely flat, as well.

b. Set up the recording plate holder on the metal slab. The bottom of the magnets now have a smooth surface to stick to. Rotate the magnets until they are best attracted to the tabletop and each other.

Strong magnets can be difficult to move around on a metal surface. Be sure you can easily separate the magnets and slip the card between them *in the dark*. You don't want to bump the object or scratch the glass recording plate while loading or

Fig. M2.7. A white card placed between the magnets. The object is positioned behind the card.

unloading the holder. (If your magnets are too strong to separate easily, you may have to pre-position one and add the second magnet as the plate is loaded into the plate holder.)

Step 5: Construct a shutter.

Equipment needed:

> 1 - black cardboard card (20.32 cm [8 inches] by 25.40 cm [10 inches]) and a way to hold it upright (another piece of cardboard, a heavy can, etc., and tape)

> or, 1 - cereal box (or similar-sized box that will stand upright)

Using a Shutter

It's easier to let laser light reach the recording plate during the exposure process by lifting a shutter than by turning the laser on and off for each shot. In fact, since you need to let the laser warm up and stabilize for 3 to 5 minutes before making an exposure, using a shutter is necessary. The shutter will also screen the recording plate from the laser light so you won't expose the recording plate until you are ready to do so.

Here is another method you can use for making a shutter:

Cut a piece of black cardboard that is tall and wide enough to completely block all the light from the laser. It should suffice to make the shutter as tall as the tops of your component holders and 15.24

cm [6 inches] to 20.32 cm [8 inches] wide. Make a stand or base so the shutter will stand upright on its edge. You can fashion an easel-type stand by taping a cardboard support to the back of the card. Or, you can tape the card to a sturdier object that will act as a base (a can works well).

Module 3

Component Setup

This module explains how to arrange the components used in the hologram recording process.

Module 3 Goal

Your goal is to properly position the two component holders, the vibration isolation table, the recording plate holder with the target card, the shutter and an object in preparation for an exposure.

Introduction

Once you have prepared your laser and built all the necessary components for recording a hologram, it is time to arrange them. The distances and angles have all been figured out for you. However, it is up to you to position all the components properly and to aim the laser beam accurately. Take your time. Remember that stability should always be an overriding concern. If you notice that any of the components you have assembled are the least bit shaky, it's best to rebuild them or reposition the setup.

Note to Instructors

The activities described in this section are especially appropriate for any student interested in optics. Related topics include lenses, refraction and reflection.

Step 1: Choose a good room to set up in.

One of the most basic and important considerations in making holograms is to set up your components in the darkest, quietest and most stable place you can find. Here are some points to consider when choosing a room to work in.

1. You should have adequate space. Your hologram recording setup will measure several feet in length and a foot or so in width, so you need at least that much space to work in. You will be performing some production steps in the dark. A place with plenty of elbow room is best so you do not inadvertently move or knock over a component.

2. The room should be dark. Ideally, you would be in a room sealed off from all light, noise and vibration. This is often impractical, but you need to find the closest situation. A basement, interior room, or large closet is better than a room with windows. If the room has windows, they must be able to be completely covered so that *no* light enters the room during your exposure

and processing. Unlike conventional photography, there is no camera body to protect the hologram "film." The unexposed recording material will just be sitting out in the middle of the room. Sunlight or lamplight will ruin it.

3. The room should be quiet. A room that can be made completely quiet is best. (Sound is vibration and we want no vibration!) That means no fans, heaters or air conditioners should be on during exposure. No refrigerators or other appliances should be operating. Water running through pipes, toilets flushing and doors slamming in the same building are potentially dangerous, too. If you can hear it — stay clear of it.

4. The room should be stable. Passing cars, trucks, trains and even airplanes create vibrations that are too small for you to see or hear but are damaging to our hologram recording process nonetheless. Any vibration you can feel in the ground, through the floor or in the building is to be avoided. Deep, low rumbles are especially bad. If you must work in a room that occasionally vibrates, time your hologram exposure to avoid passing traffic.

Even changes in temperature can create invisible air currents that cause your setup to move, so pick a room that stays at a constant temperature.

5. The room should have electrical and darkroom access. You will need an electrical outlet you can plug your safelight (or an extension cord) into. If your room has no outlet, make sure you can run an extension cord (under the door) without letting light or sound in. Keep all electrical cords and devices away from all liquids.

After exposing your hologram, you will need to develop and process your recording plate in the darkroom that you will prepare in the next module. If you choose to set up your darkroom in the same room as your optical setup, be aware that you will be working with the liquid photography developing chemicals. These chemicals often splash or spill and they can permanently stain rugs, draperies and other furniture. Therefore, we recommend that you work in a utility room, workroom or photography studio.

If you must work in a "regular" room in your house, chose one that has furnishings you can cover and protect. A bathroom may sound like a silly place to work, but it usually has a flat floor, electricity, running water and ventilation — all desirable features for a holographer.

If you arrange your optical setup and darkroom in different rooms, be prepared to walk from one to the other while holding your exposed recording plate *in complete darkness*. You can shut off all the lights or you can use a light tight box to transport your plate in.

Step 1.1: Pick a good location in the room to set up the components.

The floor usually moves less than any other surface in the room, so we recommend that you set up there. Floor space nearest a wall is usually more stable than the center of the floor. (See figure M3.1.) If you must set up on a table or on a countertop, pick a low, stable (practically immobile) one. A heavy table is better to work on than a desk.

Step 2: Arrange the components.

Equipment needed:

 1 - laser holder

 1 - lens holder

 1 - vibration-free table

 2 - magnets

 1 - small object

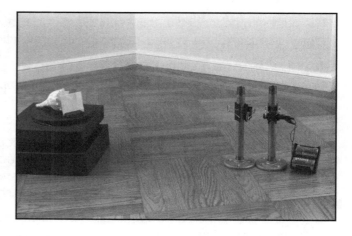

Fig. M3.1. The main components for recording a hologram arranged in a corner of the room.

1 - white card (6.35 cm [2 ½ inch] square)

1 - meterstick, yardstick, tape measure or ruler

1 - shutter

Step 2.1: Set up the main components.

The first thing to do is to line up the laser holder, lens holder, vibration isolation table and shutter.

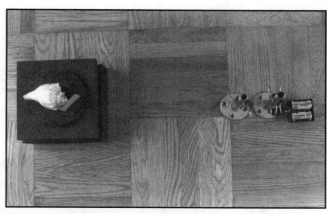

Fig. M3.2. An overhead view of the hologram recording setup before the distance between the lens and the recording plate has been measured. Note that the shutter has not yet been positioned and that the recording plate holder has been placed at an angle (see step 2.3).

a. Position the laser holder on the right-hand side of your work area. The laser should be horizontal with the beam end facing left.

b. Position the lens holder on the left-hand side of the laser holder so that the bases almost touch. (See figure M3.2.) The distance from the beam end of the laser to the lens should measure 2.54 cm–12.7 cm (1 - 5 inches). 7.62 cm (3 inches) is optimal.

c. Position the vibration isolation table on the left hand side of your setup so that the "front" center edge of the table (the side that faces the lens) is 53.34 cm (21 inches) from the lens.

d. Place the recording plate holder (two magnets and the white card) on the vibration isolation table two or three inches back from the front edge of the table. Position the magnets and the card so that the card is parallel to the edge of the table.

Remember that the white card represents the recording plate. It is necessary to use a card since the lights in the room are still on; a real recording plate would be exposed and ruined. A white card also makes it easier to see the laser light during the beam alignment process.

e. Reposition the magnets until the top center edge of the card (which is standing upright between the two magnets) is 60.96 cm (24 inches) from the lens. Be sure that the recording plate holder is sitting securely on the table and there is still several inches of room left on the table behind the card for the object.

f. Check this measurement again. The 60.96 cm (24 inches) distance between the card and the lens is a crucial one.

g. Position the shutter between the lens and the vibration isolation table, so that if the laser were on and aimed through the lens, the shutter would block the beam from reaching the recording plate. It is best to place the shutter closer to the lens than to the table.

Step 2.2: Align the beam.

The next thing to do is to aim the beam so it covers the recording plate and illuminates the object.

a. Turn out most of the lights in the room. The room should be dark enough so that you can see the laser beam, but light enough to see what you are doing.

b. Remove the shutter from the beam path.

c. Make sure that no one is looking directly at the beam end of the laser.

d. Turn on the laser. If there is dust in the room you may see a beam of red light exiting the laser. A bright red dot should appear wherever the laser is aimed (towards the vibration isolation table). If the lens is in the path of the laser beam, move the lens holder a bit to the side, so that the beam bypasses the lens and shines directly on the white card in the recording plate holder.

e. Adjust the height of the laser/clip assembly by raising or lowering the height of the spring clip on the support pole so that the beam strikes the very center of the card. (See figure M3.3.)

f. Position the lens holder next to the laser holder so that the beam passes through the lens on the way to the recording plate holder. Adjust the height of the lens/clip assembly so that the beam passes through the exact center of the lens. (See figure M3.4.) It is very important to center the beam precisely.

Fig. M3.3. The spot on the white card is the laser beam aimed at the center of the "recording plate" before the beam has been expanded. The object is behind the card.

When you are centering the beam in the lens, notice that the beam shifts position when it passes through the edge of the lens, which is a tiny bit thicker than the middle part. This is due to *refraction*. Refraction refers to the bending of light which occurs when it passes through transparent materials of varying thickness, or to be more correct, from a medium of one refractive index to that of another. The *refractive index* is a measurement of the velocity of light in air compared to the velocity of light in another refractive material (like glass) for a given wavelength.

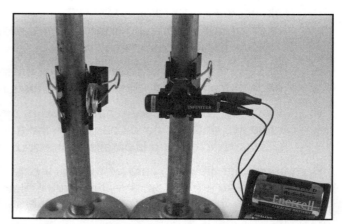

Fig M3.4. The laser pointer (with external power supply) aimed through the center of the lens.

The lens will expand the beam. You should see a red circle of laser light on the white card. The beam should be about 7.62 cm [3 inches] in diameter. The beam may have a slightly rectangular shape. It may appear speckled. *Speckle* refers to the grainy appearance objects have under laser light.

You want the expanded beam to cover the entire white card, but not to overlap it too much. You can adjust the size of the beam by moving the lens holder closer or further away from the laser holder. Moving the lens away from the laser and towards the vibration isolation table will make the beam smaller. Moving the lens closer to the laser will make it bigger. You may need to reposition the lens/clip assembly on the lens holder so that the lens remains centered in the beam path as you make adjustments.

Note: If for some reason you still cannot get the beam to cover the white card completely and evenly, you can try increasing the distance between the lens and the recording plate holder by several centimeters (an inch or two). This small adjustment should not effect your exposure but be aware that as the expanded beam distance increase, less light reaches the recording plate and the exposure time must be increased to compensate. Professional holographers with large recording setups are sometimes required to make exposures lasting minutes.

g. When the beam covers the card evenly, mark the positions of all the components so that if you need to move them, you can reset them in the exact same place.

h. Turn off the laser in between steps in order to conserve the batteries.

Step 2.3: Reposition the card.

If you were to replace the white card with a glass recording plate and shoot the hologram with the laser beam hitting the plate directly, some of the light waves would reflect off the front surface of the glass plate and bounce back towards the laser. If you were to reconstruct this hologram with the appropriate light source, the source's light would reflect directly back to your eyes and obscure the three dimensional image.

To solve this problem during the recording, you need to angle the glass recording plate so that the reconstructing beam during reconstruction is directed away from your eyes and the three dimensional image can be seen.

You want the most light you can get to pass through the plate in order to expose the emulsion and illuminate the object. More light means a shorter exposure time. The shorter the exposure, the less chance that vibrations from the surrounding environment will ruin your hologram. Therefore, you can perform one more step to maximize the amount of light striking the object and recording plate. If your laser beam happens to be polarized, placing a transparent material (such as a glass recording plate) at a predetermined angle (*Brewster's angle*-56 degrees*)* will result a in the maximum amount of the laser beam being transmitted and the minimum amount being reflected.

More importantly, this procedure makes the finished holographic image easier to view.

a. Rotate the recording plate holder clockwise so that the incoming laser beam hits the white card on a 45 degree slant (as pictured) rather than dead on. The card should be angled so the incoming beam strikes the front of the plate from the right. (See figure M3.5.)

b. Turn on the laser, darken the room and see how the beam covers the card. The spread beam may now look oblong, rather than circular, but the laser light still should be covering the card. You are trying to get consistent and complete coverage. Repeat step 2.2, if needed.

Step 2.4: Position your object.

a. Place your object behind the white card so that it almost touches it. During the exposure you will have to remove the white card and replace it with a glass recording plate under a dim safelight or *in the dark*, so leave a little room (approximately .65 cm [¼ inch]) between the object and the recording plate holder. You do not want to accidentally bump the object when loading the glass plate in to the holder.

b. Turn the front of the object towards the glass plate, not towards the laser beam. After the hologram is done, you will be looking at the holographic image "through" this piece of glass, so the object should face the viewer.

c. Remove the white card, but keep the magnets in place. The laser beam should be illuminating the object from the side.

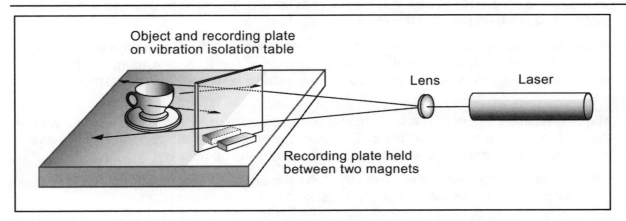

Fig. M3.5. A diagram of the hologram recording setup. Notice the position of the recording plate and the object.

Step 2.5: Stabilize the object.

It is imperative that the object stays completely motionless during the exposure. Read Chapter 4 about "object requirements." If your object isn't heavy enough and it needs to be attached to the table or secured in some way, do it now. A fast-drying glue or epoxy works well. Allow adequate drying time. A clamp or even double-sided tape may work. Avoid using rubber cement or any pliable adhesives.

Step 3: Make the final adjustments.

Now it's time to make any final adjustments that are needed to your optical setup. Here is a checklist:

1. Stability. Check the stability of each component by gently rocking each one with a touch of your finger. Slight movement is cause for concern. Make sure the laser holder and the lens holder are firmly planted. Make sure the spring clips are clamped firmly around the laser, lens, clips and poles. Make sure the isolation table is stable. Make sure the magnets can hold a white card upright. Make sure the object is immobile on the table, or is securely attached to it. Make sure the shutter will not fall over.

2. Power/wiring. Check your batteries or power supply. If you are using an external power supply, make sure all connections are secure. Test your on and off switch. Make sure you can turn on the laser without disturbing the beam's alignment.

3. Beam alignment. Turn your laser on. Check to see that the beam enters and exits the center of the lens. Place the white card in the recording plate holder. Make sure the card is fully covered with laser light.

4. Object illumination. Remove the white target card from the recording plate holder. Pretend there is a glass plate in the holder between you and the object. Position yourself so that you are looking through the imaginary plate at the object. Do not look towards the laser. Examine the object while it is illuminated in the laser light.

 Safety Note: Your eyes will be at laser beam level, and even though the beam is spread out by the lens, it is best not to look directly into any laser light source.

5. Do you see spots on the object? If you notice any dark spots on the object, it is very likely there are still tiny particles of dust or dirt on the lens. Try wiping the lens with a soft cloth to clean it. You shouldn't have to remove the lens from the clip assembly to do this unless it is extremely dirty.

6. Do you see lines across the object? If you notice a series of dark stripes on the object, it may indicate you have a bad lens or a bad laser.

 Try rotating the lens in the clip assembly. If the stripes disappear or change position, you know the lens is causing them. Try rotating the lens again to minimize the problem. (You can also try shining the laser beam through the lens slightly off center, though this may cause your beam to spread differently. You may have to readjust the position of the lens holder so that the beam fully illuminates the object.)

 If the lens is not the culprit, it could be the laser. Make sure you have given the laser enough time to stabilize. Five minutes with the beam continuously on is usually adequate. (Remember to use your practice set of batteries if you are using a laser pointer with internal batteries.)

 You may find that rotating the laser in the laser/clip assembly may help. Typically, you will get the best results when the on/off button faces directly up (towards the ceiling). The pre-wired laser diode casing may have a mark on it that indicates the up position.

 If these methods don't help, you should try using another laser if that is at all practical. If not, you may proceed, but be aware that your results may be less than optimal.

Step 3.1: Draw a sketch.

a. Sketch the object showing how it looks under laser light, so that you can compare it to the image in the finished hologram.

b. Replace the white card in between the magnets.

Step 4: Set up the shutter.

a. Place the shutter between the lens and the card. Make sure the shutter blocks the beam from reaching the card.. (See figure M3.6.)

b. Turn off the laser.

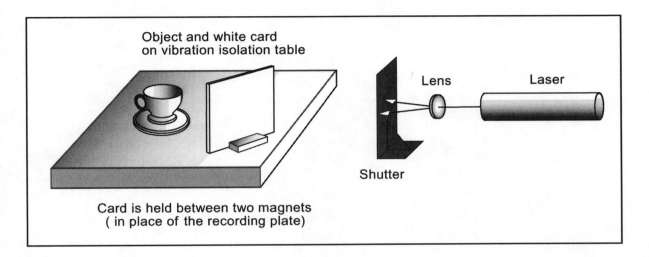

Fig. M3.6. The hologram recording setup with a shutter in place.

Module 4

Photochemistry

This module explains how to mix two developer solutions and a bleach solution.

Module 4 Goal

Your goal is to mix chemical solutions in a safe manner and to properly label the containers.

Introduction

Now that you have arranged the hologram recording setup in preparation for making an exposure, it is time to set up the darkroom. A darkroom is employed because after the hologram recording plate is exposed, you will need to develop and process the plate without exposing it to light again. In actuality, you may work under a dim green safelight, since the recording material you are using is not sensitive to that color light.

The hologram recording material you are using in this experiment is a clear piece of glass that has been coated with a gelatin containing a light sensitive, silver halide compound. Laser light is capable of changing the atomic structure of the compound. In brief, the darkroom processes will create a permanent and useful image from the silver halide material altered by the light during an exposure.

You are going to first immerse the plate in a chemical solution called a *developer*. The developer converts the silver crystals that have been exposed to light into a larger grain of silver metal. After a certain amount of time in the developer, you will wash the developer off the plate, thereby stopping the development process. Next you will immerse the plate in another chemical solution called *bleach*. Bleaching increases the diffraction efficiency of the hologram, making the hologram brighter. Then comes another wash. After the plate dries, a three dimensional holographic image should be visible when viewing the plate under proper illumination.

Important Safety Tips: It is highly recommended that an assistant help you perform the procedures in this module. Since you will be working with photography processing chemicals, it would be best to have an adult help you — especially someone who could assist you if you required medical aid, or someone with knowledge of photography developing procedures.

In the event of accidental exposure or spills it is best to have access to running water when handling chemical solutions. If possible, set up your darkroom equipment in, or close to, a utility sink.

Note to Instructors

The activities described in this section are especially appropriate for any student interested in chemistry. Related topics include photosensitive materials and photography developing procedures.

Equipment needed:

1 - thermometer capable of measuring 37.7 degrees Celsius (100 degrees Fahrenheit)

• - a way of heating water (stove, microwave, etc.)

• - a pot that can hold 800 ml (approximately 27 fluid ounces, U.S.) of water

1 - disposable funnel *

1 - measuring cup that can hold 800 ml (approximately 27 fluid ounces, U.S.) of water

3 - plastic gallon "milk" jugs with screw-on lids * (1 gallon, U.S. = 3.78 liters)

l - JD 2 processing kit

1 - felt-tipped marker or pen

1 - pair of scissors

1 - thick plastic trash bag with ties

• - 3.78 liters (1 gallon, U.S.) of distilled water (for chemical solutions) **

• - a nearby sink with running water (for cleaning and safety)

* you must throw these away after use as they will have chemical residue on them!

** **Use distilled water!** It is highly recommended that you use distilled water when mixing up processing solutions as it's considered "pure" and chemically inert. The chlorine and/or other chemicals in "regular" tap or bottled water could adversely affect the chemical solution. Jugs of distilled water are available at many large grocery stores.

Additional safety equipment needed:

2 - pairs of goggles

2 - pairs of plastic gloves

2 - aprons

2 - dust masks

• - paper towels

• - newspaper

• - a sturdy work table

Always wear eye protection, a dust mask and gloves when working with chemicals!

IMPORTANT: Darkroom Safety Precautions and Procedures

The photochemicals recommended in this book are considered relatively safe and are appropriate for home or classroom use as long as standard laboratory safety procedures are followed. Treat them with the same respect accorded to potentially hazardous household cleaning agents, garden sprays and workshop materials. Normal safety precautions include:

- Have a telephone readily accessible and the phone numbers of your doctor, nearby hospital and poison control center readily available.

- Be prepared for unexpected situations. Keep the following list of chemicals handy so that you can tell a medical staff exactly what chemicals you were working with in the event of accidental harmful exposure. Discuss with your assistant what to do if a harmful situation should occur beforehand.

- Always store chemicals in sealed containers out of the reach of children (preferably in a locked storage area).

- Always read the labels and warnings on the supplier's packaging.

- Always label newly mixed chemical solutions.

- Always dispose of chemicals safely and in accordance with local statutes.

These chemicals should not be breathed, ingested or touch your skin or eyes. They can cause blindness or skin irritation. Before mixing any chemicals, put on your goggles, gloves, aprons and masks. Work in a well ventilated area.

In case of accidental exposure: When working with these chemicals have some cold tap water running in a nearby sink. If you do get chemicals on your skin or in your eyes, flush the affected area with lots of running water immediately. Call for medical assistance.

In case these chemicals are swallowed: Call a poison control center immediately.

These chemicals can permanently stain clothes and furniture. Lay some newspaper down to protect against spills. Have a lot of paper towels ready to wipe up any spills that occur. Work on a sturdy table or on the floor. **In case of spills:** If you do accidentally knock over a solution of chemicals, make sure you are wearing your gloves, goggles and apron when soaking it up. Do not breathe any fumes. Dilute the spilled solution with more water if possible. Immediately put all wet paper towels or newspaper in a sealed trash container.

Copy and post this list of chemicals where you can reach it, if necessary:

Catechol (pyrocatechol) is a toxic central nervous system depressant; methemoglobin former and convulsant; a severe eye, skin and mucous membrane irritant. It is also a skin sensitizer. Induce vomiting and seek medical aid if ingested. Poisoning may affect the liver and kidneys.

Urea and **Ascorbic Acid** may irritate the eyes and skin. Not for internal use.

Sodium Bisulfate is a skin irritant. Do not touch or inhale. If swallowed, do **not** induce vomiting.

Potassium Dichromate is toxic. A tiny amount of the solid chemical or the solution can burn and ulcerate skin or cause severe eye damage. In addition, all chromium compounds are potential carcinogens. Do not touch directly or inhale. The solid powder is also an oxidizer, making it a potential fire hazard. It is best to make a solution of the chemical immediately after opening its package.

Sodium Carbonate, Anhydrous. Avoid breathing its dust. If swallowed, induce vomiting. Seek medical aid.

Sodium Sulfate. Not for internal use.

Step 1: Open the processing kit.

a. Unpack the JD-2 hologram processing kit. You will see seven sealed and labeled plastic bags. Each contains a powdered chemical. Do not open the bags yet!

The JD-2 hologram processing kit makes three solutions: Developer part A, developer part B and bleach.

b. Arrange the sealed plastic bags into three groups.

 1. Developer part A – Catechol; Ascorbic Acid; Sodium Sulfate; Urea

 2. Developer part B – Sodium Carbonate, Anhydrous

 3. Bleach – Potassium Dichromate; Sodium Bisulfate

Step 2: Label the gallon jugs.

You will use plastic gallon jugs as mixing and storage containers for your processing solutions. You will only mix up one liter of liquid in them, but they are good containers to use: hard to knock over or break. It is very important to label them so that no one will accidentally touch or drink the chemical solutions.

a. Label the first gallon jug with the marker. Write "Chemicals. Do not drink! Developer Part A" in big letters on all sides of the container.

b. Label the second gallon jug, writing "Chemicals. Do not drink! Developer Part B" in big letters on all sides of the container.

c. Label the third gallon jug, writing, "Chemicals. Do not drink! Bleach" in big letters on all sides of the container.

Step 3: Put on your safety gear.

a. Put on your gloves, goggles, dust masks and aprons.

Step 4: Mix Developer Part A.

To best activate this mix, it's best to warm the distilled water before using it. A temperature of 37.7 degrees Celsius [100 degrees Fahrenheit] is recommended.

a. Warm up 750 ml (approximately 25 ½ fluid ounces, U.S.) of distilled water and pour it in the jug labeled Developer Part A.

b. Place the funnel in the jug. Have your assistant help hold the funnel.

c. Cut off a corner of the plastic bag labeled Catechol. Pour all the contents into the funnel and down into the jug. Do not breathe in any of the dust or fumes. Immediately place the empty plastic bag in the trash bag.

d. Cut off a corner of the bag labeled Ascorbic Acid. Pour all the contents into the funnel and down into the jug. Do not breathe in any of the dust or fumes. Immediately place the empty plastic bag in the trash bag.

e. Cut off a corner of the bag labeled Sodium Sulfite. Pour all the contents into the funnel and down into the jug. Do not breathe in any of the dust or fumes. Immediately place the empty plastic bag in the trash bag.

f. Cut off a corner of the bag labeled Urea. Pour all the contents into the funnel and down into the jug. Do not breathe in any of the dust or fumes. Immediately place the empty plastic bag in the trash bag.

g. Pour another 250 ml (approximately 8 ½ fluid ounces, U.S.) of distilled water into the jug. Room temperature water (approximately 20 degrees Celsius [68 degrees Fahrenheit]) is fine. You don't need to heat it further. Remove the funnel (avoid drips) and place it in the running water in the sink. Wash it thoroughly so it does not contaminate other solutions.

You now have four bags of chemicals mixed in 1 liter (approximately 34 fluid ounces, U.S.) of distilled water in a gallon jug labeled Developer Part A.

h. Put the lid on securely and swish the mix around until no solid particles are apparent. It is very important to make sure that the powders are fully dissolved in the solution.

Step 5: Mix Developer Part B.

a. Heat up 800 ml (approximately 27 fluid ounces, U.S.) of distilled water and pour it in the jug labeled Developer Part B. Heat to 37.7 degrees Celsius (100 degrees Fahrenheit).

b. Place the funnel in the jug. Have your assistant help hold the funnel.

c. Cut off a corner of the plastic bag labeled Sodium Carbonate, Anhydrous. Pour all the contents into the funnel and down into the jug. Do not breathe in any of the dust or fumes. Immediately place the empty plastic bag in the trash.

d. Pour another 200 ml (approximately 7 fluid ounces, U.S.) of distilled water into the jug. Room temperature water (20 degrees Celsius [68 degrees Fahrenheit]) is fine. You don't need to heat it further. Remove the funnel (avoid drips) and place it in the running water in the sink. Wash it thoroughly under lots of running water so it does not contaminate other solutions.

You now have 1 bag of chemicals mixed in 1 liter (approximately 34 fluid ounces, U.S.) of distilled water in a gallon jug labeled Developer Part B.

e. Put the lid on securely and swish the mix around until no solid particles are apparent. It is very important to make sure that the powders are fully dissolved in the solution.

Step 6: Mix the bleach.

a. Heat up 750 ml of distilled water (approximately 25 ½ fluid ounces, U.S.) into the jug labeled bleach. Room temperature water (approximately 20 degrees Celsius [68 degrees Fahrenheit]) is fine. You don't need to heat it further.

b. Place the funnel in the jug. Have your assistant help hold the funnel.

c. Cut off a corner of the plastic bag labeled Potassium Dichromate. Pour all the contents into the funnel and down into the jug. Do not breath in any of the dust or fumes. Immediately place the empty plastic bag in the trash bag.

d. Cut off a corner of the plastic bag labeled Sodium Bisulfate. Pour all the contents into the funnel and down into the jug. Do not breath in any of the dust or fumes. Immediately place the empty plastic bag in the trash bag

e. Pour another 250 ml (approximately 8 ½ fluid ounces, U.S.) of distilled water into the jug. Room temperature water (approximately 20 degrees Celsius [68 degrees Fahrenheit]) is fine. You don't need to heat it further. Remove the funnel (avoid drips) and place it in the running water in the sink. Wash it thoroughly under lots of running water.

You now have 2 bags of chemicals mixed in 1 liter (approximately 34 fluid ounces, U.S.) of distilled water in a gallon jug labeled Bleach.

f. Put the lid on securely and gently swish the mix around until no solid particles are apparent. It is very important to make sure that the powders are fully dissolved in the solution.

Additional Safety Precautions:

• Place all three jugs in a secure place until needed. A locked cabinet or closet is good.

• Placing the jugs on the floor or on a low shelf (in a locked storage area) is safer than placing them on a high shelf. (It is better to risk kicking a jug over than having it pour onto you, and the jugs are less likely to break open the less distance they could fall).

- Keep your safety equipment on as you clean up your work area.

- Any implement, paper towel, newspaper or used gloves should be thrown in the plastic trash bag. Double-bag it if possible, and tie it closed. You do not want anyone to open the bag and touch the empty bags of chemicals or contaminated trash inside.

Module 5

The Darkroom

This module explains how to set up the darkroom in preparation for hologram developing and processing.

Module 5 Goal

Your goal is to prepare the darkroom for processing your exposed hologram recording plate.

Introduction

Now that you have mixed the primary photochemicals, it is time to arrange the darkroom in preparation for an exposure. Since the developer is a two-part solution, it needs to be mixed together just before you use it (to make sure it is fresh). In addition, you will be labeling the necessary processing containers and setting up a work area.

Step 1: Find a good location.

Equipment needed:

 1 - jug Developer Part A

 1 - jug Developer Part B

 1 - jug Bleach

 1 - green safelight

 3 - large Styrofoam or plastic cups or similar sturdy plastic containers at least 7.62 cm (3 inches) wide. (You will have to fully immerse a glass recording plate measuring 6.35 cm [2 ½ inches] square in it, without danger of the container tipping over.)*

 1 - 7.57 liters (2 gallons, U.S.) of distilled water

 2 - buckets that can hold at least 3.78 liters (1 gallon, U.S.) each

 • - a nearby sink with running water

 1 - clothespin (to use as tongs)

 • - newspaper

- • - paper towels

- • - a timer or watch visible in the dark that can measure seconds and minutes

- • - A light tight box**

- 1 - felt tipped marker or pen

- • - a 6.35 cm (2 ½ inch) square card

- • - a measuring cup

- 1 - wooden or plastic stick for stirring

Optional: 1 small bottle of Kodak PhotoFlo™ 200 solution. PhotoFlo™ prevents water spots from forming on glass plates and photographs. It is not necessary to use it in order to process a hologram, though it does make the final result look better. It is recommended for use when the highest quality result is required, such as for science fairs. A bottle cost less than $10 and is available at most photography supply stores.

*About Processing Techniques

Conventional photographers and many holographers use plastic trays as processing containers. During processing, they lay the exposed recording plate down horizontally, emulsion side up (so it won't get scratched) in a tray full of solution, and then they agitate (rock) the tray. The goal is to continually put fresh solution over the top surface of the plate by vigorously swirling the solution around in the tray. The more fresh solution that reaches the emulsion, the better the result. The tongs are used to move the plate around in the tray and lift it into the next container. However, this processing method can cause splashing and spills if you are not familiar with it.

In an effort to avoid splashing and spills, it is recommended that you try what may be a more familiar technique – the vertical "dipping" method. This involves grasping the exposed recording plate with a clothespin and repeatedly dipping and swirling the plate in a cup filled with solution. Try to keep the plate fully immersed. Do not let the plate sit for more than a few seconds without swirling it. Continuous swirling and dipping will allow fresh solution to react with the exposed emulsion.

Note: If you are already familiar with conventional darkroom processing techniques and have trays and tongs, feel free to use the technique you are most comfortable with. The trays and tongs method is proven. More important, trays are harder to knock over than cups.

**Getting to the Darkroom

It's best to arrange your darkroom components on a sturdy table or countertop close to where your recording set up is located. After making an exposure, you will have to carry the glass recording plate from the vibration isolation table to a container holding the developer solution in the dark (or by the light of a dim green safelight). Think about how best to do this beforehand. If your recording setup is not in the darkroom, you will have to seal the exposed recording plate in a light tight box and carry it there. Any box with thick cardboard sides, a tight lid and sealed edges works fine.

Temperature Considerations

All processing procedures should be carried out at room temperature (20–24 degrees Celsius [68–75 degrees Fahrenheit]). An optimal temperature for all working solutions is 22 degrees Celsius (72 degrees Fahrenheit). The temperature between solutions should not vary more than 3 degrees.

Step 2: Label the cups (or trays) and buckets.
a. Place newspaper down on all work surfaces. Have paper towels ready in case of spills.

b. Label one cup #1 Developer Parts A&B.

c. Label one bucket #2 Developer Wash.

d. Label one cup #3 Bleach.

e. Label one bucket #4 Bleach Wash.

f. *Optional*: Label one cup # 5 PhotoFlo™ solution.

g. Grab the 6.35 cm (2.5 inches) card with the clothespin and pretend to immerse it in cup 1 while the cup is still empty. Make sure the plate can fit in the cup completely and you have enough room to swirl the plate around a little bit. If the plate does not fit, you need to get bigger cups. (See figure M5.1.)

Fig. M5.1. The containers used in the darkroom. Note that the card (with the clothespin attached) fits into the cup.

Step 3: Review the processing procedures.

a. Skip to Module 7 and read about what you will be doing to process your hologram. Review these darkroom procedures before making an exposure. Be aware that the processing steps detailed in Module 7, steps 1–5 must be performed under the safelight in a dark room.

b. Pretend you are actually performing all the processing procedures so you can anticipate any logistical problems you may face. Solve these problems now.

Step 4: Mix the two-part developer.

You will be using a two-part developer solution to process our holograms. To activate this solution, Developer A must be thoroughly mixed with an equal amount of Developer B before the recording plate is immersed. You can mix the two parts together in cup 1 once you determine how much of each solution to pour in. Be aware that placing the glass plate in the cup will raise the level of the liquid a bit and you don't want the cup to overflow.

a. Before filling cup 1, figure out how much total liquid it would take to cover the recording plate once you immerse it in the cup. The plate (6.35 cm [2.5 inches] high) must be fully covered by the two-part developer, so having a little more solution in the cup is better than less. Draw a corresponding line on the cup.

b. Now draw a second line halfway between the bottom of the cup and the first line. The idea is to pour equal amounts of the two developing solutions into the cup using the lines you drew as a reference point. (If the cup has very slanted sides, you may want to use the measuring cup and some water to figure out where to draw the lines. Do not pour any developer into the measuring cup unless it is disposable.)

c. Carefully pour enough Developer A from the gallon jug into cup 1 until it reaches the lower line. Put the lid back on the jug and return it to a safe place.

d. Carefully pour an equal amount of Developer B from the gallon jug into the same cup (cup 1) to reach the top line. Put the lid back on the jug and return it to a safe place.

e. Use the stirring stick to thoroughly mix the two solutions. You should have at least 3–4 inches of the two-part developer solution in cup 1.

Safety Note: Be careful not to spill the cup over! This solution is potentially hazardous. In addition, it can stain clothes and furniture.

Step 5: Prepare the developer wash.

Pour a 1/2 gallon of distilled water into the bucket labeled Developer Wash.

Step 6: Prepare the bleach.

Pour enough bleach solution from the gallon jug into the cup labeled Bleach to fully immerse the recording plate. Put the lid back on the jug and return it to a safe place.

Safety Note: Be extremely careful not to spill the cup over! This solution is potentially hazardous. In addition, it can permanently stain clothes and furniture.

Step 7: Prepare the bleach wash.

Pour 1/2 gallon of distilled water into the bucket labeled "Bleach Wash".

Step 8 *(optional)*: Prepare the PhotoFlo™ solution

Follow the instructions on the label of the bottle of PhotoFlo™ to mix enough solution to fully immerse the recording plate.

Step 9: Find a place to dry the recording plate.

Once the plate has been washed (or soaked in PhotoFlo™), it needs to be drip-dried in an upright position (on an edge). Find something you can lean the recording plate against while it dries. Put down a paper towel to absorb any runoff.

Step 10: Position the safelight.

Plug your safelight in, turn it on. Acclimate your eyes to the green light. Position it so it barely shines on your work area. You will need to work under the safelight while loading the recording plate, using the developer, developer wash and bleach, so make sure your entire work area is adequately illuminated.

Note: If your hologram recording setup is located in a different room than your darkroom, you may want to utilize a second safelight, rather than moving one from place to place (or going without).

Step 11: Practice using the timer.

Practice timing the processing steps. You will need to time 7.5 minutes, 3 minutes, 30 seconds and 3 minutes again. Make sure under the safelight you can see the second hand and the minute hand on your watch, timer or stopwatch .

Module 6

Loading the Plate

This module explains how to prepare the hologram recording setup for exposure.

Module 6 Goal

Your goal is to check the optical configuration one last time and load the glass plate in the recording plate holder in preparation for an exposure.

Introduction

At this point in the experiment you have built all the necessary components and set them up. In addition, you have prepared the darkroom. Now it's time to double-check the recording setup and to load the recording plate into the recording plate holder. Although this procedure sounds extremely easy, you will be performing under a dim green light. If the recording plate is accidentally exposed to red laser light or is not positioned correctly, the hologram will not be recorded and you will have wasted a lot of your time. Therefore, it is best to practice this step before attempting it. To avoid accidental exposure, experienced holographers commonly load the recording plate in the dark. You may want to try this as you become more proficient.

Note to Instructors

The activities described in this section are especially appropriate for any student who has an interest in photography and lasers. Related topics include photosensitive materials and lasers.

Equipment needed:

> 1 - pre-assembled optical setup
>
> 1 - package of holographic recording materials (6.35 cm [2 ½ inches] square glass plates)
>
> 1 - white card (6.35 cm [2 ½ inches] square)
>
> 1 - safelight
>
> 1 - small knife (or scissors) capable of cutting a small piece of tape
>
> 1 - lint-free handkerchief or clean small cloth
>
> *Optional*: 1 shoebox (or similar box that has solid and opaque sides and a tight-fitting lid)

Step 1: Check the alignment of the optical setup.

After your darkroom is prepared, it's time to check your optical set up one last time before you make an exposure.

a. If you are using a laser pointer powered with the manufacturer's original batteries, load your fresh "exposure" set. You do not want to accidentally move the laser out of position by changing batteries once the setup is finally aligned.

b. Darken the room enough to see the beam, but still keep it light enough to work around your setup without accidentally bumping it.

c. Turn on the laser.

d. Remove the shutter. The laser beam should already be aimed through the lens at the white card, which you previously placed in the recording plate holder. Although it is at an angle to the incoming beam, the white card should be completely covered by a red circle of light. (See figure M6.1.)

Fig. M6.1. The lens should spread the laser beam enough to completely cover the white card (dotted line). The spread beam may be elliptically-shaped, since the card is angled in relation to the beam.

Possible Problems and Solutions

Your goal is to get the card covered evenly by the laser beam in order to expose every part of the recording plate with the same amount of light. Bright areas are receiving more light, darker areas less. (See figure M6.2.) If there are very noticeable differences in beam intensity, three minor adjustments might correct these problems.

Fig. M6.2. Three drawings showing an uneven beam pattern on the card.

1. Try repositioning the lens. Make sure the beam is traveling through the center of the lens. Move the lens pole/base assembly closer to the laser pole/base assembly, if possible. Moving the lens closer to the laser should make the beam spread more, which often provides more complete coverage over the recording plate. A last resort: If your lens has any imperfections that cause uneven illumination, you can try aiming the beam through another section of the lens, or angling the lens a bit.

2. Try repositioning the laser. Don't move the pole/base assembly from where you have placed it, but you can move the laser/clip assembly up or down a tiny bit. Do not tilt the laser — it should remain horizontal. You can also try rotating the laser slightly in the spring clip. Typically, you will get the best results when the on/off button faces directly up (towards the ceiling).

3. It is not recommended that you make any major adjustments to the vibration isolation table, but if you move the recording plate holder a little further away from the lens, the expanded beam should fully cover the plate. Rather than move the recording holder and object, it would be best to slide the entire table back an inch or so. The recording plate holder should not be moved too much further from the lens than the 60.96 cm (24 inch) distance recommended.

Step 2: Prepare the room.

a. Position the safelight so it barely illuminates your workplace.

b. Put the shutter in place between the lens and the recording plate. You do not want any laser light to accidentally reach the plate.

Step 3: Practice loading the plate

It is very useful to practice loading the recording plate between the magnets without accidentally bumping any part of the setup. Use the white card instead of an actual glass plate.

a. Remove the card from the holder. Place it securely back in the plate holder between the magnets.

b. Tap the top edge of the card to make sure it is seated firmly. Squeeze the magnets together to make sure the card does not move.

c. Remove the card.

Step 4: Examine the package of recording plates.

Examine the package of recording plates. It should be well sealed: a box within a box.

a. Carefully slice any tape sealing the edges of the outer box with a knife (or scissors) so it will be easy to open in the darkened room.

b. Read the outside of the box. It could be labeled "emulsion side down" or "emulsion side up". If it is, figure out which direction the emulsion side faces even if you have to turn the box over as you unpack it. In some instances, the label will be on an inner plastic wrapper.

Step 5: Open the box of glass plates.

a. Turn off all the lights except for the safelight. The slightest bit of light creeping under the door or through a window can expose your recording plate and ruin all your work, so check for light leaks and eliminate them.

b. Put your gloves on. Open the package carefully and remove one plate, noting the emulsion side. Avoid touching the face of the plate. Handle it by the edges. Remember that you are handling a piece of cut glass that could have rough edges or tiny chips of glass on it, so be very careful.

Remember that the emulsion side is the side of the glass recording plate that has been coated with a photosensitive-laced gelatin. It is impossible to see the emulsion coating, though it is always important to know where it is. Sometimes it is possible to "feel" it — the gelatin in the emulsion makes the surface of the plate a bit tacky if touched with a slightly moistened fingertip. If you try this, only touch the corner of the front and back parts of plate. Put your glove back on.

c. Reseal the box. It is important to reseal the box in the original manner to ensure that it is completely light-proof. If you have an assistant, it's useful to hand the plate to him or her while you reseal the box – but make sure to explain which is the emulsion side.

A useful tip: If you need to set aside the plate you removed while you repack the box, set it emulsion side up on a lint-free handkerchief (or clean cloth). The handkerchief should be lint-free so that dust does not contaminate your recording plate. The emulsion side can be slightly sticky, so if it's possible, it's better to lean the glass plate upright against a wall so that even less dust could get on it. Avoid breathing or blowing on the plate.

d. *Optional*: Place the resealed package of plates into another lightproof box that has a tight lid. This extra step protects the unused recording materials even more.

Step 6: Load the glass plate.

a. Carefully place the glass recording plate between the magnets in the same position the white card was in.

b. Face the emulsion side of the recording plate toward the object. (See figure M6.3.) If you have forgotten which is the emulsion side, set the plate in anyway. If you do place the plate in the "wrong" way you can still record a hologram, though it may be dimmer than if you had faced the emulsion towards the object.

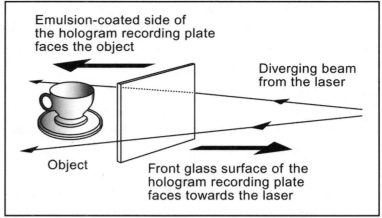

Fig. M6.3. Position the recording plate so that the emulsion side faces the object.

Note: It is imperative that the glass plate be seated firmly between the magnets and that the bottom edge of the plate is flush with the vibration isolation tabletop. Gently push down on the top edge of the plate to make sure it is firm and stable. Make sure it does not wiggle the slightest bit up and down, back and forth or sideways. If it does move, try repositioning the magnets slightly without changing the position of the plate.

Step 7: Make the environment quiet.

a. Notify all people in the vicinity you are about to make an exposure and ask them to please remain stationary and silent until you are done. A flushing toilet, footsteps, passing traffic or even an airplane flying overhead will all cause vibration. The more vibration you can eliminate or avoid, the better your chances of success.

Try to minimize the vibrations coming from the surrounding environment prior to and during the exposure period.

b. This is also the time to listen for sounds and feel for rumbles and air currents. If you hear or feel anything, search for the source of the vibration and stop it until after you have made your exposure. Turn off all nearby electrical appliances including stereos, radios, air conditioners, washers, dryers and refrigerators (if practical). Anything that hums or rumbles could be trouble.

Step 8: Allow the room and recording setup to stabilize.

It's best to remain motionless in the room for at least 10–15 minutes so all the components can stabilize. Even imperceptible temperature fluctuations (from your body heat) can ruin your recording, so don't touch any of the components.

Note: 10 to 15 minutes may be all that's possible to wait in a classroom situation before making an exposure. Generally, the more time you allow your setup to stabilize, the better your chances of success. If you must leave the room during the stabilization period, wait about 5 minutes after re-entering before you make an exposure. Be sure not to let any light in when you leave or re-enter!

Module 7

Making the Exposure

This module explains how to expose the hologram recording plate.

Module 7 Goal

Your goal is to successfully expose the hologram recording plate.

Introduction

At this point your recording setup has had a chance to stabilize and your darkroom is prepared for processing. Once you think you will have at least 15 seconds of uninterrupted silence, it's time to expose your recording plate.

Note to Instructors

The activities described in this section are especially appropriate for any student who has an interest in holography, lasers and optics.

Equipment needed:

 1 - complete recording setup with shutter in place

 1 - timer, watch or stopwatch

 1 - felt-tipped marker

 1 - light tight box (if needed)

Step 1: Expose the recording plate (15 seconds).

a. Check that the shutter is still in place, blocking the laser beam. (Remember, in the last module you left the laser on so it would be "warmed up" and ready for an exposure.)

b. Stand or sit very still for a minute and mentally review what you are going to do. You need to be able to reach the shutter and lift it out of the way without moving any other component and without disturbing the environment. To avoid causing vibrations some holographers lift the shutter off the floor and hold it for 30 seconds or so while it still blocks the beam. Then they move the shutter out of the way of the beam. Move slowly and deliberately.

c. Remove the shutter. You should see the laser light illuminating the recording plate and your object.

d. Count 15 seconds.

e. After 15 seconds, place the shutter back into the beam path. Make sure it is firmly in place.

Step 2: Remove the exposed plate from the holder.

a. Turn off the laser.

b. Notice which side of the recording plate faced the object. Hopefully, the emulsion side did.

c. Use a marker to place a very small dot on the top right-hand corner of the side of the recording plate that faced the laser. Hopefully, the glass side of the plate did but if not, don't worry! (See figure M7.1.) If the dot does not wash off during darkroom processing, it will help you position the plate later in the viewing process.

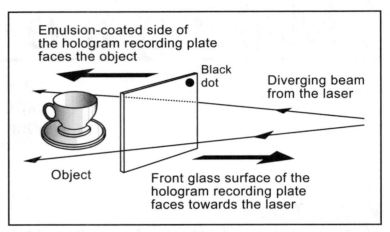

d. Carefully remove the recording plate from between the magnets. Handle the plate by the edges.

An important handling tip: It is important to know which side of the exposed recording plate is the emulsion side and which side is the glass side throughout the next steps. When handling the plate, turn the emulsion side towards you whenever the plate is upright. Keep the emulsion side facing up whenever the plate is flat. (See figure M7.2.)

Fig. M7.1. Place a small dot on the upper right-hand corner of the front (glass) surface of the recording plate.

e. Carry the recording plate into the darkroom without exposing it to any light except for a dim safelight. You can carry the plate in a light tight box if your recording setup is not in the same room.

Fig. M7.2. Keeping track of what side of the recording plate is the emulsion side will prove useful as you transport the plate.

Module 8

Darkroom Procedures

This module explains how to develop and process the hologram once it has been exposed.

Module 8 Goal

Your goal is to develop and process the recording plate after it has been exposed to laser light.

Introduction

The darkroom should be completely set up and ready. The sooner the exposed recording plate is immersed in developer solution, the better. For practical purposes and safety, it is advisable to have two people perform the following processing steps.

Note to Instructors

The activities described in this module are especially appropriate for any student who has an interest or previous experience with photography darkroom techniques. Related study topics include photochemistry.

Step 1: Perform a final check.

a. Check to make sure all the chemical solutions and baths are accessible.

b. Check to make sure all the lights (except for the green safelight) are out.

c. Check to make sure a timer is accessible and viewable.

Step 2: Put on safety gear.

Equipment needed:

> 2 - pairs of goggles
>
> 2 - pairs of plastic gloves
>
> 2 - aprons
>
> • - paper towels
>
> • - newspaper

a. Put on your gloves, goggles and aprons.

b. Review safety procedures with your assistant. Know what you are going to do if you accidentally spill or splash a chemical solution.

Step 3: Attach a handle.

Equipment needed:

 1 - clothespin to use as tongs

Grab the "top" edge of the exposed recording plate with a clothespin. Position the clothespin in the center of the plate, but do not obscure the plate too much. You do not want to damage the emulsion. And you do not want to cover up too much image area. Keep the clothespin attached to the plate until the final drying step. If it slips off, grab the plate by the edge again.

Step 4: Immerse and agitate in developer solution (7 minutes, 30 seconds).

a. Use the clothespin as a handle and immerse the recording plate in cup 1 (the two-part developer solution). Hold the cup with one hand while you hold the clothespin with the other. You do not want to knock over the cup.

b. Constantly swirl the plate around in the cup to get fresh developer continually on the plate. Constant and vigorous agitation of the plate is necessary for this step to work properly.

Note: It's not advisable to keep dipping the plate in and out of the cup — you want to keep the emulsion in constant contact with the developer unless you are checking it (see below).

c. After three minutes take the plate out of the developer for a few seconds and examine it by holding it up to the safelight and looking through it. Repeat this procedure every minute or so. Watch what happens to the plate during the developing process. The parts exposed to laser light and the developer solution should slowly and steadily darken.

d. After 7 minutes 30 seconds, remove the plate from cup 1 and proceed to the next step. Ideally, you want to stop the developing process when the plate is almost completely dark and is very hard to see through. If the plate turned opaque before this suggested time, it indicates that the plate was overexposed (received too much light). If the plate did not turn opaque in the suggested time, it indicates the plate was underexposed (it did not receive enough light).

Step 5: Immerse and agitate in developer wash (3 minutes).

a. Immerse the recording plate in the bucket labeled Developer Wash. You are trying to rinse off all traces of the two-part developer solution with a water bath in order to halt the chemical reaction.

b. Swirl the plate around in the water gently and continuously.

c. After 3 minutes, remove the recording plate from the bucket and proceed to the next step.

Step 6: Immerse and agitate in bleach solution (30 seconds).

a. Immerse the recording plate in cup 2 (the bleach solution). Hold the cup with one hand while you hold the clothespin with the other. You do not want to knock over the cup.

b. Swirl the plate around in the cup gently and continuously.

c. Watch what happens to the plate in the bleach solution. All the dark areas should steadily and gradually disappear.

d. After 30 seconds the plate should be clear again. Remove the plate from cup 2 and proceed to the next step. If the plate has not cleared, leave it in the bleach until it is clear (or until you notice no more change taking place).

Step 7: Immerse and agitate in bleach wash (3 minutes).

a. Immerse the recording plate in the bucket labeled Bleach Wash. You are trying to rinse off all traces of the bleach solution with a water bath in order to halt the chemical reaction.

b. Swirl the plate around in the water gently and continuously.

c. After 3 minutes, remove the recording plate from the bucket.

You can now turn on the room lights. If you hold the recording plate up to the light it should have a slight yellowish cast.

Step 8 *(optional)*: Immerse in PhotoFloTM (1 minute).

This step is optional. You can have the room lights on during this procedure. PhotoFloTM is a solution that prevents water spots from forming on glass or photographs. It is harmless to the skin. Performing this step will not affect the quality of the hologram itself, but by eliminating dried water spots it may improve how the image looks.

a. Immerse the plate in cup 3 (the PhotoFloTM solution).

b. Swirl the plate around in the cup gently and continuously.

c. After 1 minute, remove the recording plate from the PhotoFlo™ solution.

d. Lean the plate against a vertical wall or upright holder on a paper towel so the water will drip off. You can remove the clothespin handle.

Note: If the clothespin creates streaks where the PhotoFloTM didn't reach, it is permissible to soak the plate without using the clothespin. Since the solution is harmless to skin, you can handle the plate by the edges with gloved hands.

Step 9: Clean the darkroom.

Keep your gloves, protective eyewear and apron on when cleaning the darkroom.

a. When processing 2.5 inch x 2.5 inch (6.35 cm x 6.35 cm) plates, 12 ounces (360 ml) of the developer components A & B combined will process 4 plates. You're combined developers will stay active for 2 weeks if kept in a 12 ounce (360 ml) glass jar that is tightly sealed. Since you have mixed 60 ounces (1800 ml) combined of both components A & B (30 ounces each (900 ml)) in your one gallon jug, you can process a total of 20 plates. The bleach can be poured back into its jug and used repeatedly for all 20 holograms.

b. Once you have depleted your developer for 4 holograms or decide to dump the developer after less than 4 holograms, you should pour the developer solution into the bucket of developer wash. This dilutes the solution, making it safer to handle and dispose. You should always wear your gloves, protective eyewear and apron when handling chemicals.

c. Once you have depleted your bleach, you should pour the bleach solution into the bucket of bleach wash. This dilutes the solution, making it safer to handle and dispose. You should always wear your gloves, protective eyewear and apron when handling chemicals.

d. Dispose these used processing solutions in accordance with local regulations as soon as possible. Remember, we do not want any unwary person (or animal) to come in contact with them. Destroy the cups so they can not be reused. Wash the buckets out thoroughly. Wipe up any spills with a paper towel. Place all contaminated towels in a sealed trash bag.

Module 9

Drying the Plate

This module explains how to perform the final darkroom processing procedure.

Module 9 Goal

Your goal is to thoroughly dry the recording plate after it comes out of the bleach wash bath or the PhotoFlo™ solution.

Introduction

Once the recording plate has been processed in the chemical solutions and washes, it needs time to dry. The holographic image will not appear until the emulsion is completely dry and has hardened. The emulsion is a clear gelatin and silver halide mix that has been coated onto one side of the glass recording plate. The exposure and developing processes have physically altered the silver halide. The gelatin has been less affected, but it has been exposed to a variety of chemicals too. Although the gelatin is made to stay attached to the glass, it can scratch or peel off with rough handling. Excessive heat can also affect the gelatin and distort the hologram recorded in it. Therefore, it is recommended that you use the longer, air-dry method described below.

Step 1 *(recommended)*: Dry the recording plate.

Equipment needed:

 a paper towel

a. Lay a paper towel down.

b. Lean the plate upright to dry. Be careful not to scratch the glass or the emulsion side of the recording plate.

Drying typically takes 15 to 30 minutes at average room temperature. It could take longer, depending on the humidity in the room.

You can gently blot drips off the glass side of the recording plate, but only attempt to do so if you are absolutely certain which side of the plate is the glass side. Do not blot the water spots from the emulsion side — you may scratch it!

Remember, you will not see a holographic image until the emulsion is *completely* dry and the hologram is illuminated with direct sunlight or a spotlight at the proper angle.

Alternate quick-dry procedure

Equipment needed:

 1 - hair dryer

If you are running out of time and can not wait for the recording plate to be air-dried, it is possible to speed the drying process by gently blowing warm air from a hair dryer on the plate.

a. Put the hair dryer on the lowest warm air setting! Excessive heat will ruin your hologram.

b. Lean the plate upright. Be careful not to scratch the glass or the emulsion side of the recording plate.

c. Keep the hair dryer at least 30.48 cm (12 inches) away from the plate at all times! Small particles of dirt and dust can shoot out of the hair dryer and land in the emulsion. This can ruin your image.

d. Blow regular or slightly warm air across the plate. Keep moving the hair dryer so the plate does not get too warm.

Remember, you will not see any image until the plate is *completely* dry and the hologram is illuminated with direct sunlight or a spotlight at the proper angle. It is possible that the heat from the hair dryer will shift the color of the hologram to a greenish hue.

Module 10

Viewing the Image

This module explains how to reconstruct a three dimensional holographic image using the hologram that you recorded.

Module 10 Goal

Your goal is to add the final touches to your hologram and learn how to best view and display it.

Introduction

Now that your recording plate is exposed, processed and dried, it's time to examine the hologram. Assuming a holographic interference pattern was successfully recorded, you should be able to see a three dimensional image appear behind the glass plate *once you properly position the finished hologram under the right type of light*. In addition, there is one last procedure to perform (painting the back side of the plate) that will make the image much easier to see and will also protect your hologram from damage.

Step 1: Find a proper light source.

Equipment needed:

> 1 - bright point source of light (an overhead lamp with a clear lightbulb, a desk lamp with a halogen spotlight, a flashlight or a direct beam of sunlight)

To see the three dimensional holographic image clearly, you must illuminate the recording plate properly. You don't need to use a special, expensive lamp, just the proper type of light. Many ordinary household light sources can be used. A bright ray of sunlight will work well, too.

Use a single "point" source!

You need to illuminate your hologram with one beam of light that originates from a single *point source*. A point source is one that is tiny and very bright. The laser you used to make the hologram is an excellent point source, but there are other more practical means of illumination. One example is the small bulb in a flashlight. A halogen spotlight is also a good point source. The sun is another. Even a streetlight at night will work.

Avoid using long tube lights (such as the fluorescent bulbs commonly found in classrooms and offices). The tube is not a "point" source. A hologram viewed with a fluorescent light will look blurry.

Avoid using lamps that have more than one bulb; each bulb will make a separate image and the overlapping images will look blurry.

Avoid diffuse light sources!

You need to illuminate your hologram with a direct beam of light. Use a lamp that casts sharp, distinct shadows. The light bulb in the lamp should be clear glass, not coated white. Clear light bulbs are inexpensive and are readily available at most hardware stores. If you are using a household lamp with a white light bulb in it, you should replace that bulb with a clear glass one. Most halogen lamps and flashlights also have clear bulbs in them.

Again, avoid using fluorescent lights; the white-coated bulbs are diffuse light sources and will produce a blurry image. A light bulb behind a lampshade or screen is also a diffuse source and it should not be used to illuminate your hologram.

If you are viewing the hologram under sunlight, make sure it is in direct sunlight. Clouds and hazy skies diffuse the light. Make sure the sun casts sharp distinct shadows.

Step 2: Position the hologram properly.

The object of this step is to position the recording plate so light strikes it from the same direction (from the right-hand side of the plate) and at the same angle (45 degrees) that the laser beam did during the exposure.

a. Identify the emulsion side of the recording plate. Ideally, you tracked it through the entire recording and developing process. (If the dot you previously marked in the upper right-hand corner of the plate has not washed off, have the dot face you.)

b. Hold the hologram at arm's length and at eye level so that the glass faces you and the emulsion faces away. You need to look through the front of the recording plate just as it was set up in the holder during the exposure. (If the dot you previously marked in the upper right-hand corner on the glass front of the plate has not washed off, you know which edge is the top one.)

c. Stand so that the hologram is being lit from the right. Turn the plate 45 degrees so that the beam of incoming light strikes it at the same angle the laser light hit the plate during the exposure. It's easy to do this with a flashlight. If you are using sunlight or an overhead lamp, stand so the light is not coming from directly above; you want to light your hologram from the side. (See figure M10.1.)

A three dimensional image of the object you recorded in the hologram should come into view appearing behind the glass plate.

What does the image look like?

The image you see should be identical in size and shape to the object you recorded. It should look solid, but a little ghostly. It should be reddish or orange.

What if you don't see an image?

If you don't see an image at this point it could mean you are holding the plate at the wrong angle or lighting it from the wrong direction. Reread the lighting and positioning instructions. Perhaps you are holding the plate upside down or backwards. Try rotating the plate a quarter turn four times or until you see an image facing up. If no image appears, flip the plate over and rotate it another four times.

If you are holding the plate at the proper angle and have tried all 8 possible orientations and you still don't see an image, it is possible that no hologram was recorded. Proceed to the last section in this module (A Review of Common Problems and Solutions).

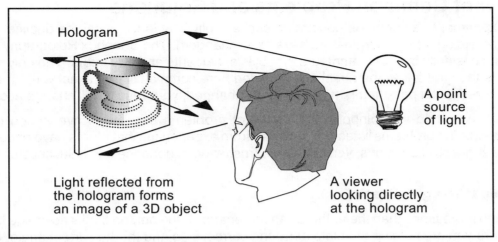

Hologram

A point source of light

Light reflected from the hologram forms an image of a 3D object

A viewer looking directly at the hologram

Fig. M10.1. Lighting and viewing the finished hologram.

Step 3: Paint the emulsion.

Equipment needed:

 1 - small can of flat black spraypaint

 1 - sheet of newspaper

Painting the emulsion of the hologram black will help you see the image better. A thin coat of black paint provides a contrasting background for the hologram image and eliminates distracting sights you would otherwise see when looking through the clear glass plate.

In addition, painting the emulsion side of the recording plate helps protect the relatively fragile emulsion against scratches and dirt. Remember that the hologram itself is recorded in the emulsion, so damage to it will affect the quality of the holographic image.

a. Put a sheet of newspaper down to protect your work surface.

b. Place the recording plate down flat, with the emulsion side facing up.

c. Spray a practice squirt on the newspaper to figure out how much paint sprays. The goal is to spray a thin, even coat of black paint across the entire emulsion. Start with a mist and add more paint slowly. Two thin coats should make the plate opaque. Avoid overspraying and drips.

d. Let the paint dry completely. You will not see an image until it does.

Hologram Care

If you positioned your plate properly during exposure, the front surface of your hologram is glass. Avoid scratching it. It can be cleaned by gently wiping with a soft cloth. Using a small amount of glass cleaner to clean it is OK.

If the front is emulsion coated, you will have to be extremely careful with it. Some holographers attach a clear cover glass over the emulsion leaving a small airspace between the two sheets of glass.

Your hologram is relatively rugged. However, extreme heat or cold could effect the emulsion. Store the hologram at room temperature.

A Review of Common Problems and Solutions

Once an experiment has been demonstrated successfully in science, it can be duplicated over and over again (providing that no parameters have been changed). The Shoebox Holography system has been used successfully by many amateurs, hobbyists, students and educators. The only requirement for success is that you follow the directions provided here completely and exactly. If, for any reason, one of the experimental parameters has accidently changed, your results will change accordingly.

This section can help you pinpoint the cause of problems that may have arisen during your experimentation. The problems listed are gathered from experiences that others have encountered. By following the suggested solutions, you can turn a frustrating experience into a successful and rewarding one.

No Image: First Thing to Check For

It's happened more times than the authors can remember — the person thinks no image is there...but it is. Make sure you are holding the plate at (a) the correct side and (b) the correct angle. One will not work without the other (i.e., if you're holding the hologram upside down, the correct angle is not going to help).

Still No Image: More Things to Check For

If, after checking to see that the position and lighting angles are correct, you still do not see any image at all, you should review the following list carefully. Several things could cause this problem.

1. An Unstable Object. Remember that the object itself must be very stable: i.e., a pewter figurine would be much more stable than a feather. But you also must make sure that the object is stable in its placement on the isolation table. It should not rock back and forth at all — with even the slightest movement.

 For instance, a commonly used "first" object is a golf ball, which seems stable. However, if you look closely at the ball sitting on the table you will notice that (because it is a sphere) only a small portion of its surface is in contact with the table, making it not a very stable at all. Repeat the experiment using an object with a larger base.

2. Out-of-sync motion between object and plate. In theory, holograms can be made during vibration, providing that the object and recording plate are vibrating together "in-phase." The whole system vibrating as a unit (in relationship to the surrounding environment) acts as a stable component.

 However, in practical applications, when the object moves and the plate does not (or vice versa), there are problems. So, if you know that your object is stable and held securely in place, you may wish to make absolutely certain that your plate is being held securely as well.

3. Over/Under-development and Exposure. It should take approximately 7 minutes or so for the developer to make your plate reach the desired density.

 If your plate is turning black shortly after you place it into the developer, your exposure time is too long. Try cutting back by 1/3 or 1/2 of the recommended 15 second exposure time and see if this helps.

 If your plate is not reaching the desired density after 7 minutes, your exposure time is too short. Try adding 1/3 to 1/2 additional exposure time.

 Remember, you want the shortest exposure time possible, so make sure to check if your batteries need to be replaced. They may be getting old and not be providing enough power to let your laser work at peak efficiency.

4. Incorrect Recording Angle. Remember, your laser light must come in at an angle to record your hologram. While it is possible to record an image with the laser light hitting the plate head-on, it is nearly impossible to view the image — due to the fact that the illuminating light will be

reflected off the plate right back into your eyes. This is why an angle is used. When you view a hologram shot using a 45 degree angle the illuminating light should hit the plate at 45 degrees and bounce off at 45 degrees (the angle of incidence equals the angle of reflection). This way the light is directed away from your eyes and the holographic image is visible.

5. Air Currents. Heating and air-conditioning causes air to move within a room. *You* can not feel it, but the hologram recording setup does. If the air between the object and plate is in motion, it will have an adverse effect on the final result. If this is a problem, you may wish to use a suitable sized cardboard box and place it over your isolation table. Just cut one end of the box out completely to allow the laser light to enter. Many holographers enclose their larger holographic tables for just this reason.

6. Improper Warm-up of Laser. Your laser needs several minutes to "warm up" and become stable. Try to have your laser on for at least 5 minutes before you conduct your exposure. This will insure that the thermal expansion in the laser diode has reached a point of equilibrium.

Very Dim Image

1. Use a brighter object. The amount of laser light that your object can reflect back to the plate plays a big role in how bright the final hologram will be. A white object will create a much brighter hologram than a dark blue object. You may wish to choose a number of different objects and place them in the spread laser beam. Notice which ones seem the brightest. These are the objects that you should choose.

2. Motion. Although the object and/or plate are not moving enough to make the object disappear completely, they may be moving enough to make the final hologram dim. As mentioned previously, check to make sure that both the plate and the object are as stable as they can be.

Black Bands Appear on the Object

This is almost always due to motion of the object. Make the object more secure or choose another object. If you hold the object in your hands for an extended period before placing it into the setup, next time you will want to allow extra time for the thermal energy to dissipate.

Parts of the Object are Missing

This is almost always due to motion of the plate. Make sure the plate is held securely in place with the magnets. If you hold the plate in your hands for an extended period before placing it into the setup, next time you will want to allow extra time for the thermal energy to dissipate.

Black Shadows Appear on the White Card

Dirty Optics. Lenses pick up airborne dust, which then settles on the glass surface. When passing the laser beam through the lens, these dust particles are carried as "shadows" in the expanding laser beam...becoming very large by the time they reach your white card and/or hologram plate. Try to keep your lens(es) clean at all times. Slight imperfections in the lens may also cause dark bands to appear as well.

Laser Is Getting Dimmer

If you notice that the laser is getting dimmer as time goes on, you may want to replace the batteries. The larger the battery, the longer it will power your diode. The small button-type batteries that came with your laser pointer are basically for using the pointer in an on/off situation, such as for presentations—they were not designed for what is called "continuous operation." If you replace those with larger batteries, i.e., AA, C or D cells, you will be able to run your laser for longer periods of time in continuous operation mode.

Plate Goes Black Immediately When Placed in the Developer

One hopes this is being caused by overexposure. Try cutting your exposure time back by 1/3 to 1/2. If this does not help, maybe the recording plates were accidently exposed to room light. Only open the plate box in complete darkness (or under a green safelight). If you think you have exposed your plates to room light, you should try using one from the bottom of the stack.

Module 11

Using Fiber Optics

This module explains how to record a hologram using a fiber optic bundle.

Module 11 Goal

Your goal is to record a hologram using a new optical component.

Introduction

The Shoebox Holography hologram recording setup employed in the previous modules is very simple. Aside from a few holders and mounts it consists of a laser, a diverging lens, a hologram recording plate and an object. The first two components in the setup are positioned together a specific distance away from the hologram recording plate (so that the laser light exiting the diverging lens spreads wide enough to cover the plate). The latter two components rest on a vibration isolation table.

What if, for some reason, you didn't have a big enough work area to place all the components? Would it be possible to make a hologram in half the space? What if the laser was in a different room from the recording plate (perhaps for safety)? Would it be possible to send enough laser light to the recording plate so that the plate is exposed in a reasonable amount of time?

The answer to these questions is yes. This module will teach you how to substitute a fiber optic bundle for the diverging lens used in the previous Shoebox Holography experiment in order to make a hologram recording setup using a different optical configuration than you used before. You will still employ a laser, a hologram recording plate, an object, a vibration isolation table and a few holders and mounts.

Note to Instructors

The activities described in this module are especially appropriate for any student who has an interest in fiber optics. Related study topics include optics, semiconductor diode lasers and digital communications.

What's a fiber optic bundle?

The term *fiber optics* was coined in 1956, though these "optical wires" were starting to be used as early as 1950 in medical devices and in industrial machinery. Webster defines fiber optics as a very thin homogeneous fiber of glass or plastic that is enclosed by material of lower index of refraction and transmits light throughout its length by internal reflections. To elaborate: A fiber optic strand is comprised of two main parts, a transparent core and a cladding (outside covering). (Note: some product catalogs use the term clad, rather than cladding.) The core is typically made from extremely pure glass, or in some instances, plastic. The cladding is made of glass or plastic that has different optical properties than the material used to make the core (specifically, a lower index of refraction). Sometimes these two components are wrapped in a plastic jacket for protection. The composite strand is so thin (most optical fibers measure 4/1000 to 8/1000 inches in diameter) it is relatively flexible, even though it may be glass. A fiber optic bundle contains a tightly packed group of fiber optic strands arranged parallel to each other.

How does it work?

When a beam of light is aimed at one end of a fiber optic strand, light enters the core and travels along through it. Instead of the beam expanding and getting dimmer with distance (like a flashlight beam aimed into the night sky) the beam exiting the other end of the core retains its shape and much of it's brightness. Why is this so? Whenever the light traveling down the core strikes the surrounding cadding, it bounces off the inner surface of the cadding at a shallow angle and is directed further down the core. (See figure M11.1.) The cadding acts as a mirror of sorts, creating a condition called *total internal reflection*, which is the basis of all fiber optics. The light does not pass through the cladding even when the fiber optic strand is curved. The light just travels around the bend, following the curvature of the strand like water flowing through a pipe. None of it leaks out. Therefore, the intensity of the light doesn't change very much as it ricochets down the fiber optic strand.

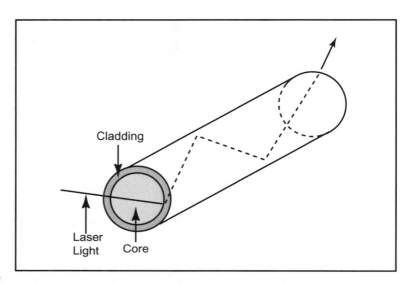

Fig. M11.1. A diagram of a fiber optic strand.

Why is it Useful?

Modern communication often relies on our ability to transmit high quality signals for very long distances. Fiber optic technology is capable of carrying signals long distances without being distorted. Therefore, the major application of fiber optics is in the field of communications.

Radio and television signals typically travel through the atmosphere for tens or even hundreds of miles before the quality of the signal is significantly diminished. With the help of electronic amplification devices, telephone and cable television signals can travel hundreds, even thousands of miles through strands of wire before the quality of the signal is adversely effected. Sending an electrical signal through wire does work well but it is much more efficient to send an optical signal composed of very fast pulses of light down a fiber optic strand. Light travels at 186,000 miles a second and the resistance it meets in a fiber optic stand is negligible. (See figure M11.2.)

Lasers are great light sources to use with fiber optics. New semiconductor diode lasers are affordable, rugged and small. They are practical to use as signal transmitters along with optical sensors (used as signal decoders). Due to both technologies' long term cost effectiveness and high performance, bundles of fiber optics are being strung thousands of miles across the globe to carry

high speed digital communications for audio, video and data transmissions.

The advantages of using light (especially laser light) traveling through fiber optic bundles for communications, rather than electrical signals traveling through wires include:

Communication System	Potential Signal Tranmission Rate (bits per second)
telephone	60,000
FM radio	250,000
television	6,000,000
laser beam	100 billion

Fig. M11.2 A table comparing the transmission rates of various communication signals.

1. Fiber optic strands can carry much more information than can be carried on copper conductors. A fiber optic cable can carry many more messages at the same time than the copper wire of equivalent diameter (40,000 compared to 3,700). This fact is very useful for the telephone industry. Using fiber optic technology, a phone conversation can be electronically converted into very rapid pulses of light, transmitted through the fiber optic cable and then converted back into sound with very little loss of quality. In addition, fiber optics systems are less expensive to operate and maintain. Conventional telephone cable contains 1800 copper wire, carrying 900 telephone conversations at one time and require signal amplification about every mile. New fiber optic telephone cables can carry 500,000 conversations at once and need amplification every ten miles.

2. Fiber optic technology is a more secure way to move information than through wires. Light does not produce an electrical signal as it moves through the fiber optic strand. This makes it difficult to detect and eavesdrop on signals passing through fiber optic bundles, unlike electronic communications that can be more easily traced and intercepted.

3. Optical signals passing through fiber optic strands are less effected by external and environmental forces than are electrical signals transmitted along a wire. Electrical signals can be disrupted by other electrical, magnetic or radio sources. Shielding wire is expensive.

4. Fiber optic technology is generally safer to use, especially in potentially hazardous environments. Electrical systems can be dangerous to use around explosive or flammable materials.

5. Fiber optic technology does not have to comply with electrical codes. Therefore it is usually easier and cheaper to install fiber optic systems than electrical systems.

Other applications

Fiber optic technology is also being integrated into medical equipment, industrial equipment and consumer electronics. The extremely small diameter of the fiber optic strands (as small as a strand of hair) allow them to be threaded through parts of the human body. By attaching cameras and magnification devices to the strands, high resolution images of the body can be transmitted and viewed by medical staff. Because they are so efficient at transmitting high speed signals, fiber optic strands are replacing wire connections in a range of digital devices. In addition, since fiber optic bundles can bend, light is not restricted to straight paths. It can be easily directed to a desired location. It is likely that strands of fiber optics will soon connect your home computer and audio/video components instead of lengths of copper wire.

Suppliers

The following Web sites supply fiber optic bundles:

http://www.edmundscientific.com (Refer to Stock number J02-544 in the Edmund Scientific Industrial Optics catalog, an unjacketed communications grade light guide. Current cost is $1.25 per foot.)

http://www.fiberoptic.com

http://www.toddsfiber.com

The Fiber Optic Hologram Recording Experiment
Equipment needed:

 1 - complete Shoebox Holography hologram recording setup

 1 - additional holder (a pole and a base). See Module 2

 1 - spring clip that opens wide enough to clamp on the pipe (5.08 cm [2 inches] wide)

 1 - spring clip that opens wide enough to clamp on the fiber optic bundle (2.54 cm [1 inch] wide)

 1 - unjacketed fiber optic strand (1 mm outer diameter) at least 213.36 cm (7 feet) in length.

 Note: You will be cutting this strand into shorter lengths. It is recommended that you start with a 10-foot strand in order to have some extra material to practice your cutting technique on and to provide you with backup strands in case of accidental breakage.

 1 - single-edge razor blade

 1 - pair of work gloves

 1 - pair of safety goggles

 1 - white target card

 1 - complete darkroom prepared for processing

The long, single strand of fiber optics recommended for this experiment needs to be modified in order for it to be effectively utilized. The core is much smaller than the output diameter of the beam emitted from the diode laser (4 mm). It would be impractical to direct the laser beam into a single fiber optic strand. A solution is to cut the single strand into seven 30.48 cm (12-inch) lengths. These can be bundled together to make a fiber optic cable that can be positioned against the beam end of the laser pointer or diode laser assembly. The bigger array of fibers can carry more light and the resulting larger beam diameter produces better coverage of the hologram recording plate. Experimental evidence demonstrates that the recording plate "sees" the 7-strand bundle as one point source.

Step 1: Cut the fiber optic strands.

a. Put on your gloves and protective eyewear.

b. Using a single-edge razor blade, cut one end of each strand perpendicular to it's axis. The goal is to create a very smooth interface on the end of each strand so most of the laser light will travel into the core. Rough or chipped ends will scatter light (which is undesirable). You should attempt to slice the strand rather than chop it. If possible, practice your slicing technique before making the final cuts.

 Note: Fiber optic suppliers sell a tool designed for this job. Also, since the fiber strand is made from a very hard plastic, heating the razor blade before making a cut can help produce a smooth cut. Be sure to mount the razor blade on a razor blade handle before attempting this.

c. Repeat the cutting process on the other end of each strand.

d. Clean your work area. You can remove your gloves and goggles once any glass shards have

been removed and disposed of. Put the razor blade away in a secure place.

Step 2. Arrange the strands in a bundle and tape them together.

a. Bundle the strands together. The goal is to make the bundle the same size as (or a bit bigger than) the laser output beam. Making the right size bundle lets you utilize most of the light from the laser. As always, the more light that reaches the hologram recording plate, the shorter the exposure time and the less chance vibration will prevent an interference pattern from being recorded. If you are using the Infiniter 200 laser pointer, a 7-strand bundle will match the size of the aperture where the beam exits.

Note: If you are using any other combination of laser and fiber strands, you may have to employ a different number of strands to make an appropriately sized bundle.

b. Adjust the strands so their ends are on the same plane. Make the bundle circular (6 strands arranged around one middle strand). Wrap the end of the bundle with tape. Tape the strands together tightly.

c. Repeat this process on the other end of the bundle.

Step 3. Position the bundle.

a. Take the lens out of the lens/clip assembly. Place it in storage where it will not become scratched or chipped.

b. Rearrange the clips so the smaller one will grasp the fiber optic bundle horizontally while a horizontal component while the larger clip holds the smaller one to the pole. You can place double-sided tape on the edges of the smaller clip to cushion and protect the fiber bundle, if you judge that necessary.

c. Insert the bundle in the smaller spring clip so that one taped end protrudes a bit from the edge of the clip and the clip is grasping the fibers behind the tape. It is all right if the clip squashes the fibers at this location. Don't grasp the fibers on the tape since this will squash the fibers and may cause the bundle to not be circular. The bundle should be horizontal and its end should be circular.

Fig. M11.3. A 7-strand fiber optic bundle (wrapped with tape) fits snugly into the end of the laser pointer. A clothespin is used to depress the pointer's on/off switch.

d. Move the pole holding the bundle as close as possible to the pole holding the laser. Stick the end of the fiber optic bundle directly against the laser output. You may have to adjust the positioning of the laser and of the bundle in order to get them close enough to touch. Unless the laser pointer's (or diode laser's) aperture is fully covered by all the strands in the bundle, you will not be taking advantage of all the light being emitted from the laser. A 7-strand bundle should fit snugly into the Infiniter 200 laser pointer's aperture. (See figure M11.3.)

Step 4: Build a third holder.

a. Build a third holder like the one that you modified in step 3.

b. Insert the bundle in the smaller spring clip so that one taped end protrudes a bit from the edge of the clip and the clip is grasping the fibers behind the tape. It is all right if the clip squashes the fibers at this location. Don't grasp the fibers on the tape since this will squash the fibers and may cause the bundle to not be circular. The bundle should be horizontal and its end should be circular. You now have a fiber optic bundle supported on both ends by a spring clip assembly. (See figure M11.4.)

Step 5. Turn on the laser.

Turn the laser on. You should see light exiting the end of the fiber optic bundle that is not touching the laser. The light will diverge.

Step 6. Insert the white card.

a. Insert the white target card into the recording plate holder (at a 45 degree angle).

b. Remove the shutter from the setup.

c. Position the third holder in front of the white card.

d. Point the end of the bundle towards the front of the card so that the distance from the fiber's output to the center of the card is 10.79 cm (4.25 inches).

Fig. M11.4. The fiber optic bundle suspended between two holders. On the left-hand side of the picture the bundle is positioned against the laser pointer. Note that screw clamps are used in this setup to hold the bundle rather than spring clips.

e. Darken the room until you see a red circle of laser light on the card.

f. You may need to move the bundle a little closer or further away from the card in order to achieve the most uniform illumination on the card. Or you may have to adjust the position of the bundle in the holder.

Step 7. Resume the Shoebox Holography experiment.

Once you have best illuminated the white card, you can resume the rest of the Shoebox Holography experiment starting at Module 6, Step 5: Open the box of glass plates. By this time you will have gained experience and knowledge from the previous experiment that you can utilize now. Depending on the amount of light that reaches the hologram recording plate, you may have to increase your exposure time beyond 15 seconds. Start at 15 seconds and increase your exposure in 15 second intervals until the best results are achieved (i.e., the finished holographic image is the brightest).

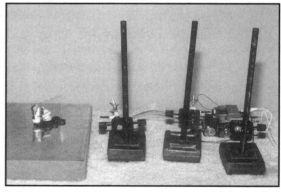

Stephen Michael successfully used the following parameters to record a hologram using a fiber optic bundle in place of the lens. For objects, he used magnets painted glossy white. (See figure M11.5.)

Recording material: glass plate type BB-640

Laser output: 4.6 mW @650nm (Infiniter 200)

Fiber output: 1.36 mW

Power at plate (center): 12 microwatts

Fig. M11.5. From right to left: The laser (with batteries attached), the fiber optic bundle (suspended between two holders) and the vibration isolation table (with recording plate and object).

Distance fiber output to plate center: 10.79 cm (4.25 inches)

Distance plate from depth of object: 0-3.17 cm (0-1.25 inches)

Exposure time: 30 seconds (trial # 1) 60 seconds (trial #2)

Developer: JD-2, 7.5 minutes, 74 degrees F.

All other development procedures followed as per book.

Note: In theory, it is possible to use a much longer fiber optic bundle. Since very little light is lost as it travels through the strands, a long bundle will work as well as a short one. You may want to try using a long bundle. If less laser light is delivered to the hologram recording plate, simply increase the exposure time.

Appendix A

An Alternate Developer-Bleach Combo for HRT
Red-sensitive BB-640 Recording Plates

Here is an alternative to using the JD-2 prepackaged developing and processing kit that is recommended. If you have experience working with photochemicals you may want to try using these formulations. These chemicals should be available at a well-stocked chemical supply house or photographic supply shop. You will need a way to measure the ingredients.

Always use proper safety procedures and laboratory techniques when handling these chemicals.

CWC2 Two-part Developer

Part A is good for one month, Part B indefinitely.

Part A solution

Warmed distilled water	500 ml
(Pyro)Catechol	10 g
L-Ascorbic Acid (Vitamin C)	5 g
Sodium Sulfite (anhydrous)	5 g
Urea	30 g

Wait at least 30 minutes for chemical activation.

Part B solution

Warmed distilled water	500 ml
Sodium Carbonate	30 g

Wait at least 30 minutes for chemical activation.

A minute or two before use, mix equal parts A & B to activate developer

The mixed solution is active for 20 minutes. Discard it after one use to ensure that each hologram has optimal development.

PBU-Amidol Re-halogenating Bleach (Phillips-Bjelkhagen Ultimate)

Potassium Persulfate	10 g
Sodium Bisulfate (or Citric Acid)	10 g
Potassium Bromide	20 g
Cupric Bromide	1 g
Amidol (add last!)	1 g

Mix one at a time, in sequence, into 500 ml warmed distilled water, then add another 500 ml distilled water to make 1 liter.

Wait at least 30 minutes for chemical activation.

Bleach can be reused a few times, and is usually good for two weeks — the red color fading to clear indicates exhaustion.

Bleach will leave permanent purple stains on everything! Handle carefully.

Processing Recommendations
Step 1: Develop plate.

Use just enough developer to cover one hologram. Develop plate for at least five minutes @ 68° F with constant agitation when using low-powered lasers.

Step 2: Rinse plate.

Rinse in distilled water.

Step 3: View plate.

View a green safelight through the rinsed plate to judge density — some variation is OK. Adjust exposure/developing time to achieve a very dark final developed density (measuring D 2-3.5)

Step 4: Bleach plate.

Bleach unfixed plate for 3-4 minutes @ 68° F until clear plus 1 minute.

Step 5: Rinse plate.

Rinse in distilled water.

Step 6: Dry plate.

Air dry plate with a low-heat blower or in a drying cabinet for approximately 15 minutes.

This procedure was suggested by the professional holographer and holography instructor, Jeffrey Murray in an article that appeared in Holography MarketPlace, 7th edition.

ALWAYS FOLLOW PROPER SAFETY PRECAUTIONS WHEN MIXING AND WORKING WITH CHEMICALS!

Appendix B

Shoebox Holography has been recommended as a useful introduction to the field of photonics.

Exploring Careers In Lasers, Photonics, And Holography

Now that you've created your first hologram & begun to explore the world of lasers & photonics, you may be wondering if this could fit in with your future career planning. Absolutely! In this section, we'll give you some information on things to consider when you're exploring careers in general. We'll also share some Internet resources that can guide you in your search for careers in the field of lasers and photonics.

Career Exploration

Would you take a trip to a country you knew nothing about? Would you go to a college that you had never heard of without doing any research? Probably not. But many people decide on their future careers without knowing anything about them. Or, they decide on a career option, but discover when they get to college that they do not have the academic background to take the courses they need to graduate. Kind of gets in the way of your plans for the future, huh?

When you start thinking about preparing for or entering a particular career, you can divide your search into 3 components—"Know Yourself," "Know the Market," and "Make the Match."

Know Yourself

Career exploration begins with you. Ask yourself these questions:

What interests do I need to have to enjoy this job? Most of us get the greatest enjoyment out of doing things that interest us. A job is no different. Make sure that any career you select is one that fits in with your interests—the things you like to do.

People who enter the field of lasers & photonics generally enjoy:

a. Figuring out how things work

b. Operating and/or fixing machines

c. Working with their hands, assembling, building, and/or repairing things

d. Planning and supervising a project

e. Drawing detailed plans or patterns and/or working with blueprints/designs

f. Courses in advanced mathematics, chemistry, physics

g. Working with others to solve a real-life problem

What abilities do I need to do well at this job? Some of us are good with our hands, and some of us are not. Some of us have strong mathematical abilities, and some of us do not. Knowing where your natural strengths and abilities lie and how these fit into your career interests is an important component of career exploration.

People in laser/photonics/holography careers generally have:

a. An aptitude in math and/or science

b. The ability to communicate and get along well with others

c. Leadership skills & good judgement

d. The curiosity and ability to solve a problem with creativity

e. The ability to gather, analyze, and evaluate data

f. The ability to define, develop, and generate ideas and test these ideas through research and experimentation.

What are my work values? What's important to me in a job? Do you want to make a lot of money? Have a flexible schedule? Work from home? Travel? Help people? Generally we are happiest with those jobs that fit in with the things that are important to us, so make sure that when you're looking at career options, you consider how the job will fit in to the things you value in life.

There are a lot of on-line resources that can help you identify your interests, abilities, and work values. Try:

1. College Board On-Line Career Assessment (http://www.collegeboard.org/career/html/searchQues.html)

2. The Career Key (http://www2.ncsu.edu/unity/lockers/users/l/lkj/)

3. University of Waterloo's Career Development Manual (http://www.adm.uwaterloo.ca/infocecs/CRC/manual-home.html)

Know The Market

Once you've identified your interests, abilities, and work values, now you can begin to explore occupations that fit in with who you are. These are some of the issues you should explore:

What jobs are available in the field? What does the job involve? What's the job description? Find out what job duties and responsibilities the job typically has. This can vary from company to company, so it's a good idea to not only look at generic job descriptions, but to also explore the descriptions for actual job openings.

Some of the jobs in the field of lasers, photonics, and holography include:

• Industrial Laser Technician

• Medical Laser Technician

• Designing & running laser light shows

• Laser Manufacturing Technician

• Optical Engineer

• Fiber Optic Packaging Engineer

• Optics/Laser Manufacturing Engineer

What kind of educational background to I need for this job? In today's economy, most jobs have fairly high educational expectations. By some estimates, up to 80% of jobs requires some education beyond high school. When you explore a career, it's critically important that you look at the courses you must take in high school and college in order to be prepared for the occupation.

Most careers in the laser and photonics fields require at least a 2-year technical or associate's degree. Higher level positions in research or management generally require at least a bachelor's or master's degree.

What's the job outlook? Is this a growing occupation? Will there be jobs available in the region of the country where I want to work? Will there be jobs in this occupation 10 years from now? Search for careers that have a strong outlook and look like they'll be around for a while.

Careers in lasers and photonics are what we call "emerging careers." Advances in the field are creating new job opportunities in a variety of industries, which may fuel extensive job growth.

·What are the salary & benefits ranges for this career? Naturally, you'll want to know how much money you can expect to make in this career. Just remember that salary ranges vary depending on the part of the country you're living in, the type of company you work for, and your level of education & experience.

What is the work environment for the career? Will you be working indoors or outdoors? Will you work alone or with others? Is it shift work? Will you be working around loud machinery?

What are the "advancement opportunities?" Most of us don't want to stay in the same job for the rest of our lives. Try to find out how you can progress in this career and what other jobs you could move into. Also find out what you need to advance. Experience? More education? Both?

To further explore answers to these questions, try these on-line resources:

1. North Central Technical College (http://www.northcentral.tec.wi.us/programs/laser/laserstart.htm) Offers an associate's degree program with descriptions of medical & industrial laser technician jobs and links to other resources.

2. Optics.org – Photonics Resources for Scientists & Engineers (http://optics.org/home.ssi) Explore job listings to get an idea of job descriptions and job requirements. There is also an excellent library of articles on lasers and photonics.

3. California Employment Development Department (http://www.calmis.cahwnet.gov/file/occguide/lasertec.htm) there is an excellent description of a laser technician, including money, outlook, etc.

4. This same site, at http://www.calmis.cahwnet.gov/file/occguide/teleprof.htm, offers descriptions of emerging careers in telecommunications.

5. Central Carolina Community College (http://www.calmis.cahwnet.gov/file/occguide/teleprof.htm) offers an associate's degree program. Also, a listing of the types of careers for which you are prepared as well as a list of the companies that hire graduates.

Make the Match

Now that you've explored your interests, abilities, and work values, and taken a look at the careers that fit in with them, it's time to make some decisions. Here are some things to consider when you're making the decision:

a. Do you have the interest and ability to do well in the field?

b. Does the field require a college degree? If it does, have you taken the right courses in high school to enter a program? Are there college programs available to prepare you with the right skills?

c. Does this career pay enough to support the kind of life-style you want to lead?

d. Does it fit in with what's important to you in a job?

e. Will there be jobs available in the career when you graduate? Are the jobs in areas where you want to live?

If you can answer "yes" to most of these questions, then you've probably found yourself a career. Is it in lasers or photonics?

This article was provided by Michele Roy of The FREEdLANCE Group for Career and Workforce Innovation.

Shoebox Holography as a Career Training Course

"Over the past decade, in work with a wide range of populations and in a wide range of career transition states (from school-to-work, to career changers in middle life or even after formal retirement), we have seen that one simple but critical success element exists to excite learners and entice them to seek a career path and/or explore work in a given industry. This simple element is motivation through curiosity and interesting tasks, and is achievable by structuring learning so that students seek out information and advice from educators, not just pouring facts into passive minds. Learning is a dish best served by a guide on the side, not a sage on a stage.

The FREEdLANCE Group for Career and Workforce Innovation has had success in our work with schools at every level, community based programs, foundations, and countless State and Federally funded employment and training efforts, by transforming educational and training environments toward such a learner centered service delivery approach. We feel Shoebox Holography is a tremendous tool for like minded policy organizations and advocates of contextual and engaging curriculum. We are pleased to support this work, and will personally advocate for its use in work we do with regional Workforce Investment

Boards, Science & Technology Centers, One-Stop Career Transition Centers, School-To-Career programs, school districts, and so on.

Shoebox Holography has unique elements (beyond the revolutionary low-cost), that are sure to ignite the career aspirations of many, and open doors for career seekers to high demand science and technology occupations and industries. Even more important, Shoebox Holography can help educators show very quickly the embedded relationship between basic math and science skills to careers. Indeed, it presents this through many multi-dimensional opportunities which have been the focal point of Tech-Prep and the Secretary of Labor's Commission on Achieving Necessary Skills (SCANs) the nation has long struggled with to mainstream in academia for all students and lifelong learners.

Shoebox Holography may not only enlighten many, but also help foster our continued global economic leadership by wowing learners and enticing them to seek careers in science and technology industries. These industries are the biggest customers of our efforts to transform knowledge supply chains, and are desperate for a skilled workforce now and to grow new leaders. We are all working collaboratively to build human resource supply chains for the future, and Shoebox Holography offers a powerful tool for a vast array of stakeholders in career and workforce development. It will serve well efforts to promote great careers in high-tech fields, rampant now with job openings and projected to continue for years to come."

William J. Freed, President & CEO - The FREEdLANCE Group for Career & Workforce Innovation

Shoebox Holography Vocabulary List

It is important to understand the definition of the following terms:

hologram

recording plate

laser

object wave

fringes

interference

interference pattern

diffraction

holographic image

parallax

coherent

laser beam

refracted

lens

object beam

reference beam

standing wave pattern

reflection holograms

transmission holograms

master hologram

embossing

embossed holograms

pulse lasers

vibration-isolation tables

continuous wave (CW) gas laser

interferometry

Holographic Optical Elements

matter

energy

photon

continuous wave transmission

pulse transmission

phase

constructive interference

Light Amplification from Stimulated Emission of (electromagnetic) Radiation.

population inversion

primary wavelength

monochromatic

conductive path

circuit

series

magnetism

refraction

refractive index

speckle

reflection

angle of incidence

angle of reflection

developer

bleach

Brewster's angle

electromagnetic radiation

kinetic energy

conservation of energy

potential energy

fiber optic

core

cladding

total internal reflection

INDEX